IMAGES
of America

SOUTHWEST
WASHINGTON, D.C.

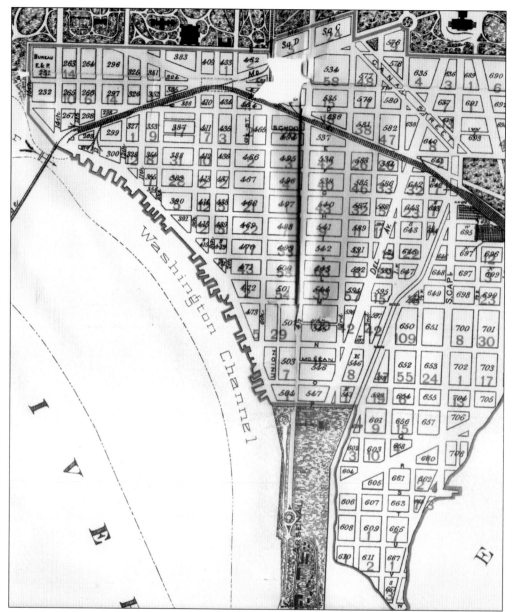

The Washington, D.C., Department of Health issued this map in 1894 to illustrate the number of outdoor privies, or outhouses, located within each block. Square designations are noted with small numerals, and the number of privies per square is noted in large numerals. The block surrounded by N and M Streets and Half and First Streets contained the largest number of outhouses in Southwest that year—109. (Author's Collection.)

IMAGES
of America

SOUTHWEST
WASHINGTON, D.C.

Paul K. Williams

ARCADIA

Published by Arcadia Publishing
Charleston SC, Chicago IL, Portsmouth NH, San Francisco CA

Printed in Great Britain

Library of Congress Catalog Card Number: 2005935864

For all general information contact Arcadia Publishing at:
Telephone 843-853-2070
Fax 843-853-0044
E-mail sales@arcadiapublishing.com
For customer service and orders:
Toll-Free 1-888-313-2665

Visit us on the Internet at www.arcadiapublishing.com

The Southwest neighborhood takes its name from the L'Enfant quadrant of the same designation, due to its proximity to the U.S. Capitol. The residential and commercial dwellings that made up the Southwest community stretched from the waterfront to the National Mall long before the federal buildings were built that line Independence Avenue today. (Library of Congress.)

CONTENTS

ACKNOWLEDGMENTS

This book would not have been possible without the support and prior work of many individuals that have assisted in documenting the history of Southwest Washington, D.C., including Jane Levey of Cultural Tourism D.C. and Margaret Feldman of the Southwest Neighborhood Assembly, who both saw a multiyear effort come to fruition with their excellent self-guided heritage trail found throughout the community on heavily illustrated trail signs and in an accompanying booklet.

Carolyn Crouch of Washington Walks often leads many interested parties along a fascinating and insightful walking tour of old Southwest that allows participants to experience the community today and to glimpse the neighborhood of yesteryear. Mary Kay Ricks is also documenting the riveting story of the slavery escape aboard the schooner *Pearl*, which will be included in a book that nobody interested in Washington history should be without.

This book has been funded in part by a grant from the Monument Mitigation Grant Fund, a joint project of Monument Realty, D.C. Preservation League, and the D.C. Historic Preservation Office, in connection with the National Trust for Historic Preservation. The views expressed by the author do not necessarily represent the views of the grant funders.

Photograph credits are listed after each image, and the following abbreviations are used: LOC (Library of Congress, Prints and Photographs Division), MLK (Martin Luther King Jr. Memorial Library, Washingtoniana Division), NA (National Archives), DCHCD (D.C. Department of Housing and Community Development), HSW (Historical Society of Washington), and NCPC (National Capital Parks and Planning).

This book is dedicated to those that called Southwest their neighborhood for many decades and for many generations, only to be relocated by the federal government beginning in the 1950s; most of them were unable to return or recognize their birthplace or childhood home.

INTRODUCTION

The Southwest neighborhood of today is a paradox; it has distinction of being one of the oldest settled communities in Washington, D.C., but it is also as one of the most recently constructed ones. The city's smallest quadrant appears to be entirely built in the 1960s, but upon closer inspection, architecture from the 18th century can be found amongst modernist architecture from the 1960s. In fact, Southwest has one of the most traumatic histories of neighborhoods in America that were subjected to 1950s idealistic planning concepts calling for the systematic razing of all the buildings. The rich and diverse community that once existed here was viewed as urban decay and virtually clear cut like a forest; tens of thousands of homes, businesses, churches, wharfs, and warehouses were removed. Urban planning went from concepts to reality between 1955 and 1965 as these residents were displaced, most of whom would not return to a home that may have been owned by a fourth or fifth generation.

With more than 350 years of history, no one book can begin to cover every aspect in detail. This short tome, however, aims to highlight the rich history of the community in hopes to enlighten, reflect, and perhaps even surprise residents and visitors alike with new photographs and tales of community life that once was and that began again as a reborn neighborhood in the 1960s.

Populated by Native Americans and mapped by Capt. John Smith in 1608, the area known as Southwest is situated on the point of confluence between the Potomac and Anacostia Rivers. The area was worked by Maryland slaves long before it became part of the 1791 plan for the city drawn up by Pierre L'Enfant, who called for its southernmost point to be a strategic military site, which it remains to this day. Land speculators built houses with varying degrees of success, a few of which remain, such as the c. 1794 Wheat Row.

The 1791 plan originally called for Southwest to include the portions completing the city square on the west side of the Potomac, now part of Virginia. What few Washingtonians also include in their descriptions of Southwest today are areas that lie to the south of the Anacostia. They include Bellevue, Bolling Air Force Base, and other Department of Defence facilities, all of which could easily fill a book of their own, and are only touched upon here.

The early port community was short lived, however, as silt infiltration limited the visiting ships to smaller boats carrying passengers, fruits, and seafood instead of warships and schooners after 1850. Washington remained small until 1865, and much of Southwest was isolated from the city by James Creek Canal and the railroad tracks while other neighborhoods blossomed. By 1870, however, Southwest had established itself as a vibrant community that attracted freed blacks after the Civil War and Jewish and German immigrants in the early 20th century in what would remain one of the most diverse neighborhoods in the city until the 1950s.

The area of Southwest now occupied by large government buildings was once part of the low-scale residential community as well. Streets lined with 1870s-era townhomes, such as Linworth Place, once stood where the Agriculture Building is today, without any evidence remaining from their 100-year existence as a neighborhood alive with children playing in the streets, baseball

games in the local fields, and generations of families raising their children and teaching their business to their next of kin. There are clues though, such as the Market Inn at 200 E Street that has served meals since 1959. The federal presence began with the Smithsonian in the 1860s and continues to this day with architecture of varying quality built since that now calls for studies for its role in history.

A series of events prompted the systematic demolition in the mid-1950s in the "Southwest Washington Redevelopment Area." Images of the area before the redevelopment had been used by Russian leaders as an example of the failure of capitalism, and Congress was intent on erasing the blighted and crowded community that featured the U.S. Capitol in the background. Efforts had been made as early as 1910 to publicize the city's crowded alleys, with new buildings built by Washington Sanitary Housing Company and with photographs by Gordon Parks in the 1940s. By the time a famous Supreme Court ruling in 1954 upheld the D.C. Redevelopment Act passed in 1945 allowing imminent domain, much of the neighborhood had been vacated in anticipation of redevelopment.

It was seen as innovative at the time: a mix of high-rise apartment and cooperative towers were built along with low-rise town homes, initially aimed at attracting a diverse ownership. By 1970, the entire community was reborn into a model neighborhood, with successes and failures in each project. Like the Oscar Niemeyer–designed Brazilian capital of Brasilia (designed and built entirely in the 1950s), the entire Southwest neighborhood's construction dates were suddenly within a few years of one another, and most traces of its past were annihilated.

Today, more than 50 years after it was built, the community once again is gaining a history, as its buildings, construction methods, and architects are being studied for their role in history, and apartments are becoming desirable by fans of the architects. Little building has infiltrated Southwest in the last 50 years, and only with the introduction of new homes along the Southwest Freeway in 2001 was a large-scale project undertaken in the community for the first time in nearly five decades.

One

EARLY DEVELOPMENT
1735–1865

Long before the plans for the Federal City of Washington were drawn by Pierre L'Enfant in 1791, the area known today as the Southwest quadrant of Washington was utilized by Native Americans for farming and access to the confluence of the Anacostia and Potomac Rivers for much of the same reasons white settlers built plantation houses along its banks. White settlers used slaves brought from the Caribbean and Africa to farm their land at such places as Gisborough, built about 1735 by Thomas Addison on what is today Bolling Air Force Base and a mansion owned by Notley Young that had no less than 265 slaves working the land by 1791.

Many early land speculators, such as the Greenleaf Syndicate, sought to take advantage of the newly planned city by building rows of impressive brick townhouses in the 1790s, but the slow growth of the city on mostly swamplands spelled financial ruin for these early builders. In the 1830s and 1840s, however, a new generation of builders and landowners began to construct elegant houses in the Southwest neighborhood close to the Capitol building and outside the military site at Greenleaf Point on today's Fort McNair.

A unique community of freed and enslaved blacks populated the neighborhood up until the Civil War, including Anthony Bowen, who lived on E Street between Ninth and Tenth Streets. He maintained a mission and day school and was an important stop on the Underground Railroad in the 1850s, with the enslaved frequently arriving at the Sixth Street wharf undercover. In 1848, a group of Washington slaves attempted an unsuccessful escape aboard the schooner *Pearl* that left from Southwest. Most of the community's landscape, however, consisted of small farms and small townhouses along with Four-and-a-Half Street, a commercial corridor lined with saloons, coal yards, and fuel supply warehouses that offset water-orientated commerce along the river.

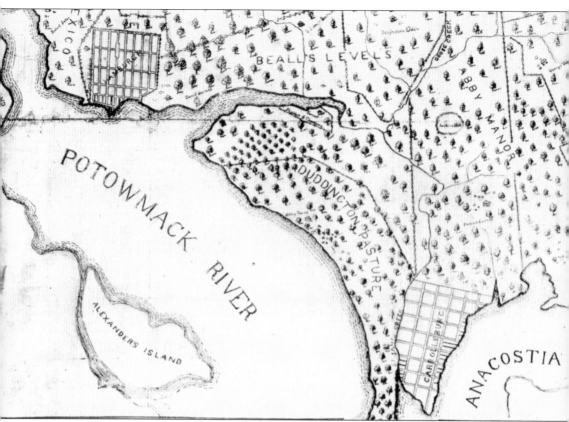

This 1792 map of Washington, D.C., shows most of what is today Southwest as Duddington's Pasture, planted with fruit trees. Notley Young's house is depicted in the grove along the Potomac River. (LOC.)

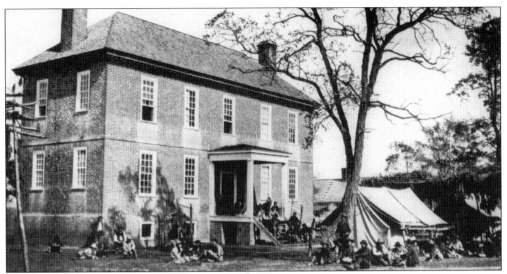

Once located on the site of Bolling Air Force Base, one of the most substantial Southern Maryland plantation houses was coined Upper Gisborough. The brick manor house was built about 1735 by Thomas Addison Jr. to replace a wood house built by Thomas Dent shortly after he was granted the land by Lord Baltimore in 1663. It was subsequently owned by such prominent families as the Shaafs and Youngs. Located directly across from today's Fort McNair, the plantation was transformed into Fort Stoneman during the Civil War, housing 30,000 horses and mules as the largest stable in the world at the time. The house burned during a dance in September 1888. The photograph seen here was taken by Mathew Brady during the Civil War. (NA.)

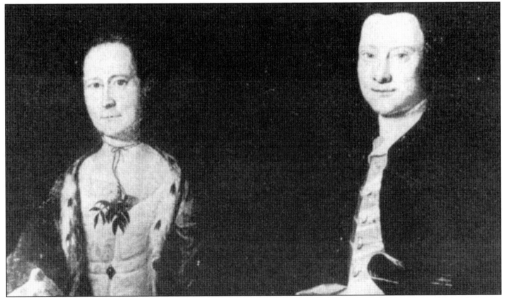

In 1791, the year that the U.S. government included what is today Southwest in its ambitious plans for a federal city, the area was largely owned by a Maryland plantation owner named Notley Young. Young's 265 slaves worked the lands for agriculture. Young is seen here with his wife; their mansion once stood near today's Banneker Circle, underneath today's L'Enfant Plaza. Young's grandson, Nicholas Young Jr., helped establish St. Dominic Church in 1852. (LOC.)

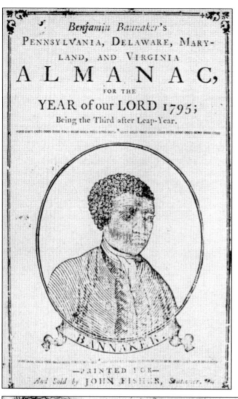

Benjamin Banneker, a freed black slave originally from Ethiopia, had already established himself as a genius astronomer and mathematician by charting the stars, tides, sun, and moon for planting and navigation by the time he arrived in Georgetown accompanying surveyor Maj. Andrew Elliott in early 1791. His calculations were needed for establishing the official boundaries of Washington. Author of a 1795 almanac for the region, Banneker was also one of the first champions of black rights, writing to Thomas Jefferson about his concerns of racial equality in the emerging republic. Banneker Circle in Southwest is named in his memory. (Maryland Historical Society.)

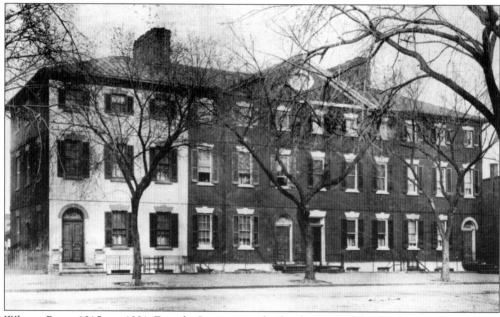

Wheat Row, 1315 to 1321 Fourth Street, was built about 1794 by land speculator James Greenleaf, who at the time controlled about one third of the available land in the city. The row takes its name from John Wheat, who once lived at 1315. Saved from the widespread demolition in the 1960s, the row was incorporated into the Harbor Square project between 1964 and 1965. (LOC.)

The large double house at 468–470 N Street is known as the Duncanson–Cranch House, and it was built about 1794. Its Federal design was attributed to William Levering, an architect for the Greenleaf Syndicate. From 1904 to 1960, the residence served as the home of the Barney Neighborhood House. It was incorporated into the Harbor Square urban renewal development between 1964 and 1966. It was photographed by John O. Brostrup for the Historic American Buildings Survey in March 1937. (LOC.)

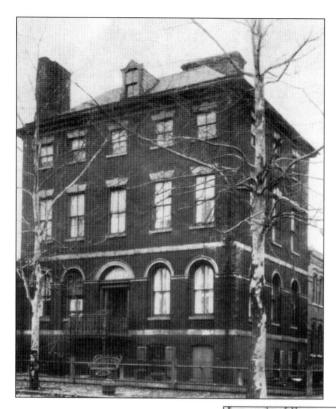

The Thomas Law House at Sixth and N Streets was built in 1794 and was occupied between 1796 and 1800 by real-estate speculator Thomas Law and his wife, Eliza Parke Custis, granddaughter of Martha Washington. The house was also sometimes called the Honeymoon House, as the young couple spent their honeymoon there. It is pictured here about 1900. (HSW.)

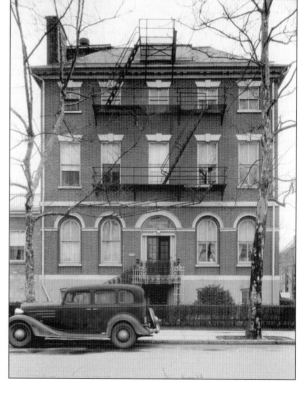

A number of important people were entertained at the Law House shortly after it was built, including the king of France Louis Philippe and the French writer Volney. Pictured here in 1936, the Law House is one of the fortunate ones to survive the urban renewal and redevelopment of the 1960s and is now part of the Tiber Island Cooperative complex built in 1965. (LOC.)

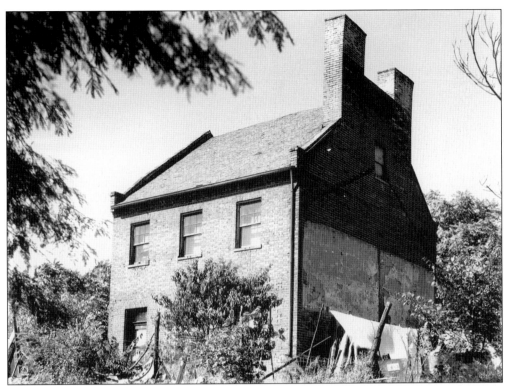

The dwelling known as the Joseph Johnson house was built at 49 T Street on Buzzard's Point by Bladensburg, Maryland, native Joseph Johnson. The Buzzard's Point area was first proposed as a settlement for Carrollsburg by a 1770 subdivision filing in Upper Marlboro, Maryland, before the creation of the District of Columbia. The house was documented in 1935 by the Historic American Buildings Survey before it was razed. (Photograph by Albert S. Burns, LOC.)

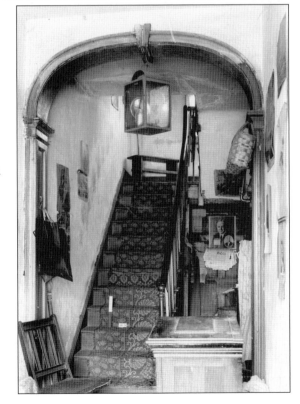

The condition of the Joseph Johnson house was documented as severely deteriorated in 1935. Despite that fact, a remarkable amount of original architectural details remained in the house 135 years after its initial construction. (LOC.)

15

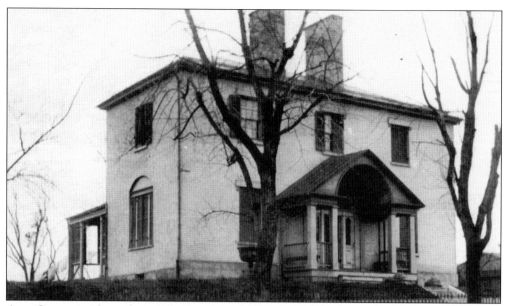

Ann Casanave, the widowed daughter of early settler Notley Young, built this fine house on the southwest corner of Fourteenth and C Streets, SW, in 1802. Built on her 800-acre parcel of land, which extended from Third to Fifteenth Streets, it was shared by her sister Eleanor Brent. Ann was the widow of Peter Casanave, merchant and one-time mayor of Georgetown. It was left to her daughter Joanna, a wife of Maj. Parke G. Howle, who used the estate as a setting for extensive social functions. The house was demolished in 1913 for the construction of the Bureau of Engraving and Printing. (LOC.)

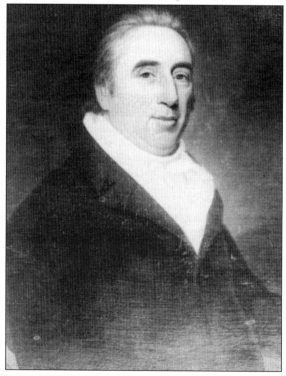

One of the early land speculators that owned parcels in Southwest near the emerging Capitol in 1791 was William Marbury, seen here. He was an inspector of tobacco at Blue Plains Point and president of the Farmers and Merchants National Bank in Georgetown, where he resided. He had purchased the Blue Plains and Addison's Good Will tracts in 1802 at a cost of $20,000 from the Addison family; this land now composes most of the Blue Plains Water Treatment Facility and Bolling Air Force Base. (LOC.)

This house at 456 N Street was built about 1817 and was one of the fortunate ones to survive the urban renewal of the community. The Federal-style residence is known as the Edward Simon Lewis House, and it was once home to newspaper correspondents Ernie Pyle and Lewis J. Heath. It was photographed for the Historic American Building Survey by John O. Brostrup in April 1936 and incorporated into the Harbor Square urban renewal development between 1964 and 1966. (LOC.)

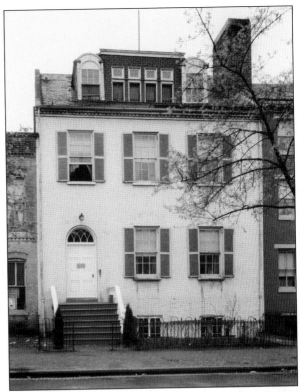

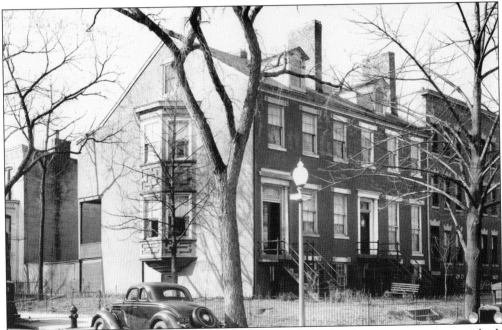

These fine examples of early residential architecture in the Southwest community were built about 1830 at 1000 and 1002 B Street. They were documented by the Historic American Buildings Survey in 1937 and were among the many victims of urban renewal demolition in the 1960s. (LOC.)

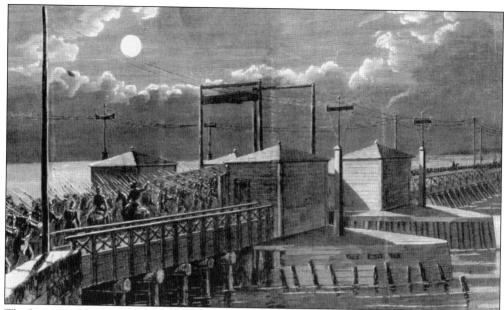

The Long Bridge once stood where the Fourteenth Street Bridge is today and was built in 1834. It was heavily used during the Civil War by Union troops and to bring supplies into the city; it was later converted into a railroad bridge for the Baltimore and Potomac Railroad. It was illustrated here for the May 1866 edition of *Harper's Pictorial History of the Civil War*. The bridge was replaced by the Fourteenth Street Bridge in 1905. (Author's Collection.)

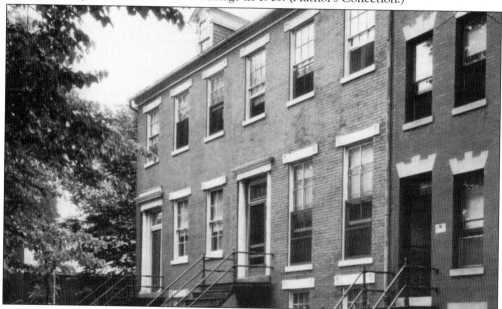

New York native Gilbert Cameron, a master stonemason, was brought to Washington, D.C., in 1847 by architect James Renwick to supervise the cutting of stone at Seneca, Maryland, for the Smithsonian Castle. Shortly thereafter, Cameron built these Greek Revival houses at 1000–1002 Independence Avenue for himself and as a rental. They remained at the intersection until 1941, when they were razed for the widening of Independence Avenue; today the site forms the entrance to L'Enfant Plaza. (LOC.)

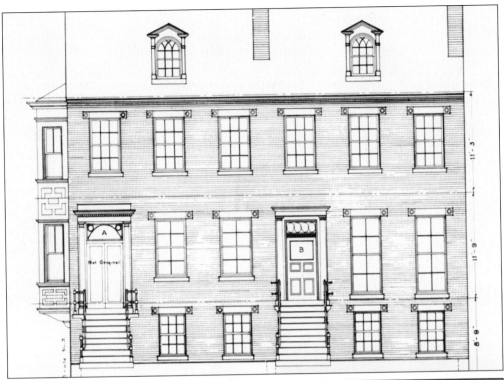

Like many of the old resources threatened in Southwest Washington and other areas of the country, the Cameron houses were extensively documented through measured drawings done in the 1930s and retained as part of the Historic American Buildings Survey (HABS) in the Library of Congress. The twin houses at 1000–1002 Independence Avenue are seen here. (LOC.)

On the evening of February 17, 1848, the schooner *Pearl* left the wharves in Southwest with 77 male and female fugitive slaves aboard. Daniel Drayton served as the vessel's captain, Edwin Sayres as the vessel's owner and co-captain, and Chester English as sailor and cook. Two local freed blacks, Thomas Ducket and Daniel Bell, organized fugitives for the escape. However, the venture was betrayed, and a steamboat was used to pursue and re-capture the fugitive slaves aboard the *Pearl*. The following day, a white mob rioted in front of the anti-slavery Washington newspaper the *National Era*, edited by Gamaliel Bailey. Drayton was found guilty and sentenced to 20 years in prison and fined over $10,000. He eventually received a pardon from Pres. Millard Fillmore four years later. (LOC.)

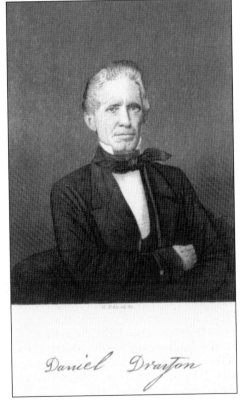

Daniel Drayton

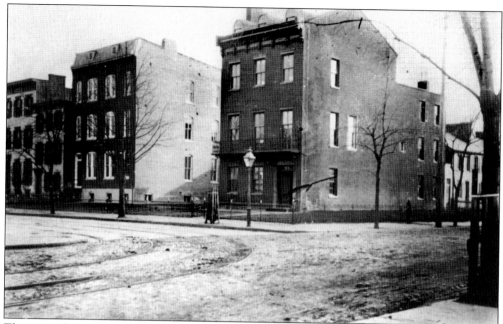

These townhouses that once stood at Fourteenth Street and Independence Avenue were built in the mid-19th century. They stood on the site today occupied by the Department of Agriculture's southern building. (Department of Agriculture.)

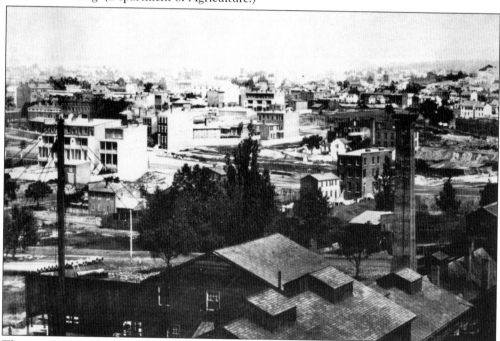

This extremely early view of Southwest, taken from the U.S. Capitol Building in 1857, shows the plethora of dwellings and small commercial buildings in the area before the Civil War. Nearly all of the buildings visible in this photograph have been replaced by large federal buildings and the urban renewal projects of the 1960s. The large chimney in the foreground was part of the stonecutter's shed being utilized for the expansion of the Capitol. (Architect of the Capitol.)

20

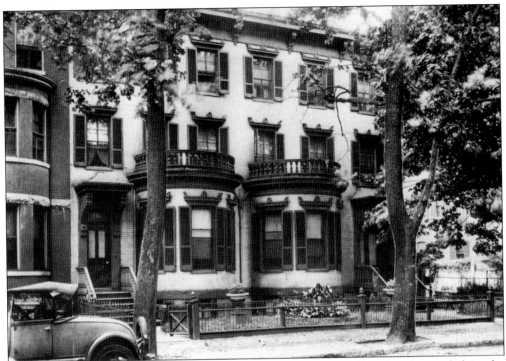

These handsome residences were built in 1860 by Charles B. Church, who resided in the dwelling at the right while renting out its twin for additional income. They were once located at 394 and 396 Eleventh Street between C and D Streets. (HSW.)

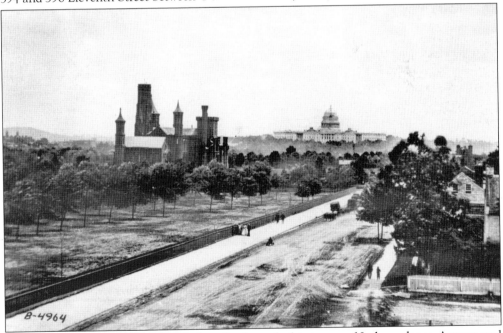

Famed Civil War photographer Mathew Brady took this image of Independence Avenue and Twelfth Street in 1863. It shows the Smithsonian Castle, which was the first area of the Mall to be landscaped, beginning in 1849 with the planting of 150 species of trees and shrubs. (NA.)

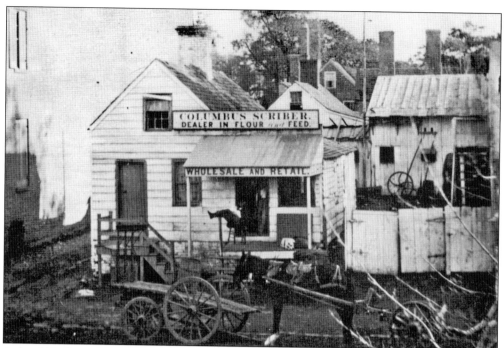

A freed black man named Columbus Scriber owned and operated this flour and feed business once located at 119 E Street. His photograph was taken on October 9, 1863, by Titian R. Peale, during the height of the Civil War. (Smithsonian.)

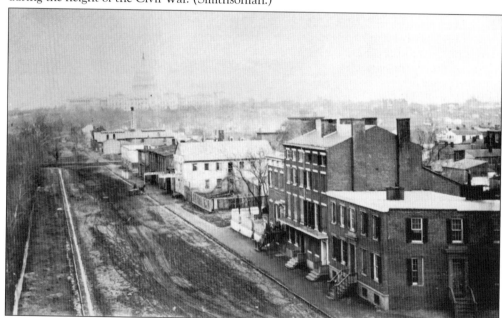

This view looking northeast along Maine Avenue was taken in April 1865; at the time, Maine Avenue ran diagonally from Fourth Street to Sixth Street through a portion of what is now the National Mall. The white building had a sign hanging over the sidewalk advertising it as the home of a brass foundry and ironworker business owned by Thomas Somerville and Robert Leitch. (LOC.)

Two

THE

MILITARY COMMUNITY

The military presence in Southwest began with L'Enfant's call for a military site on the southern tip of Greenleaf's Point in his detailed 1791 plan for the city. The Washington Arsenal was fully operational on the site by 1822, strategically placed there to protect the city from potential invasion. It became a site for manufacturing of munitions and arms for local military companies.

In 1826, the federal government constructed the Washington Penitentiary, designed by Charles Bulfinch, on the Arsenal site; it later became the site of the Lincoln conspirators' (including John Wilkes Booth) hanging in July 1865, and served as their gravesite. The Southwest portion of the National Mall was developed into the Armory Square Hospital during the Civil War, located there due to the proximity to the Southwest wharves that wounded and dying soldiers were sent to from points in Virginia. Southwest resident Anthony Bowen organized the first black regiment from Washington to fight in the Civil War.

Many of the oddities and medical curiosities from the Civil War ended up at the Army Medical Museum, founded in 1862 and built along Independence Avenue in 1886. In 1903, President Roosevelt laid the cornerstone of the building for what is today known as the National War College on the present site of Fort Leslie J. McNair, thought to be the oldest continually operated military installation in the country. World War I called for the creation of the installation known as Bolling Air Force Base just south across the Anacostia River, while World War II transformed parts of Southwest and the city into sites for temporary housing for women workers that flowed in to the city for many years during the period.

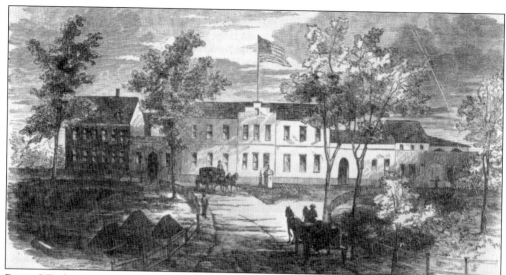

Pierre L'Enfant has called for a "great military works" at Greenleaf Point, the tip of what is Fort McNair today. The earliest Washington arsenal, seen here, was built in 1822 on the site "to secure the city from invasion." (LOC.)

The old Washington Arsenal was once located at the intersection of Fourth and P Streets, where the War College building exists today. It was strategically located at the confluence of the Anacostia and Potomac Rivers upon the recommendation of L'Enfant on his 1791 plan for the city, although its substantial buildings were not constructed until 1822. (NA.)

The Washington Arsenal became a major manufacturing site of munitions and arms for the Civil War. In June 1864, fireworks drying in the sun on the lawn ignited and flew through the window of the main workroom, where 108 women were at work making rifle cartridges. The resulting explosion killed 21 workers. President Lincoln joined a funeral possession two days later to a mass burial site in Congressional Cemetery on Capitol Hill, where a sculptural relief can still be seen today memorializing their patriotic duty. (LOC.)

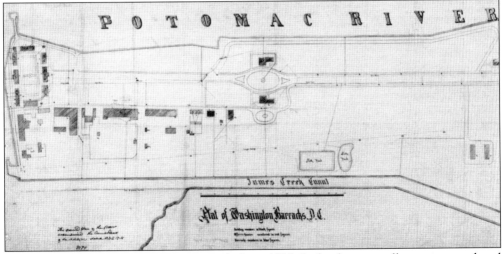

This plan shows the Washington Arsenal about 1885. Its lands eventually encompassed and combined those of the Washington Penitentiary, seen in the center. Architect Adolph Cluss was hired to design officers' quarters in 1869, and shortly thereafter, the facility was renamed the Washington Barracks. The vast majority of the buildings associated with the Arsenal were demolished between 1903 and 1907. (NA.)

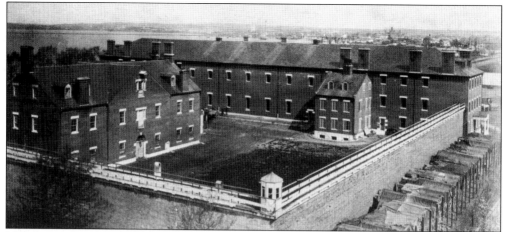

The first penitentiary established and operated by the federal government was built in 1826 on the site of present-day Fort McNair. It was designed by Charles Bulfinch, enlarged in 1831, partially razed and rebuilt between 1867 and 1869, and partially razed in 1903. Seen here during the Civil War, it was originally built to accommodate 160 prisoners in confining cells measuring only two and one half feet by seven feet in length, with openings facing alternatively north and south to prevent prisoners from passing items to one another. It was expanded in 1831 to accommodate more prisoners (black and white females and males of all ages), with additional cells, kitchens, and a wharf for the arrival of inmates transported from other states. (LOC.)

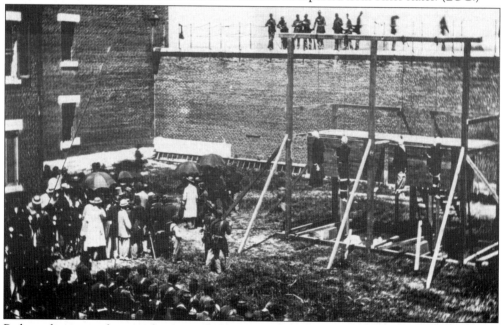

Perhaps the most infamous of activities held at the penitentiary was the trial and hanging of the Lincoln conspirators, held in July 1865. Four of the eight prisoners received death sentences and were hanged in the courtyard in front of a bevy of onlookers, most of whom received tickets to the event from the Department of the Interior. Those hanged included Mary J. Surratt, George Atzerodt, David Herold, and Lewis Paine, who were all buried on the grounds. John Wilkes Booth, who had been killed in a Virginia tobacco barn, had been buried at the penitentiary on April 27, 1865; all bodies were later removed by relatives to other locations. (LOC.)

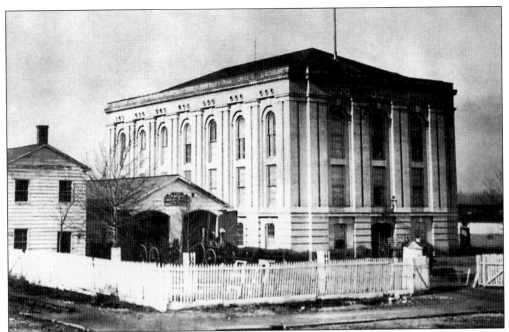

The Washington Armory, also known as the Columbian Armory, was designed by Maj. William Bell and was once located at the northwest corner of Independence Avenue and Sixth Street. Plans for the building were approved by Secretary of War Jefferson Davis in 1855. It was built to house rifles and cannons used by local militia. It was demolished 109 years later, in 1964. (LOC.)

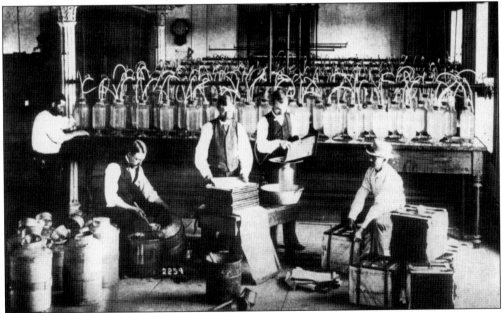

The Washington Armory served many purposes throughout its 109-year history; armory, hospital, aquarium, museum warehouse, motion picture studio, library, office building, and even a paint shop. This view of the interior from about 1890 shows employees of the U.S. Fish Commission preparing tanks of fish for shipment by rail across the country in an attempt to replenish depleted fish in lakes and rivers. (NA.)

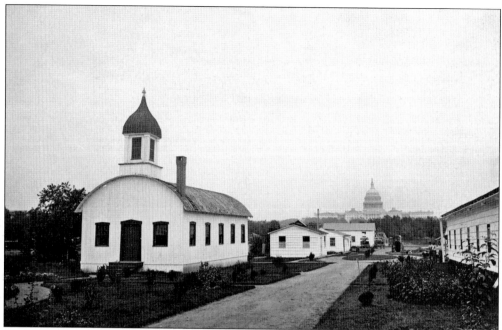

The Washington Armory drastically expanded during the Civil War to include a complex of wooden buildings stretching across the National Mall to form the Armory Square Hospital. It included this handsome chapel building, photographed in August 1865 for an album compiled by Hirst D. Milhollen and Donald H. Mugridge. (LOC.)

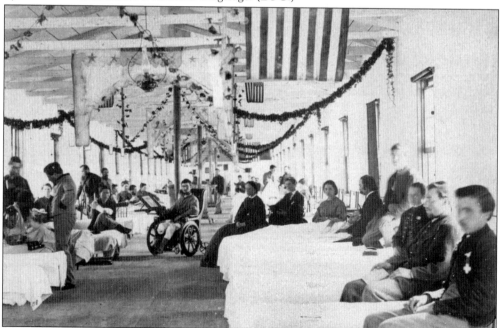

The Armory Square Hospital included approximately 50 wooden wards that extended the entire width of the Mall from Fifth to Seventh Streets. President Lincoln had the wards placed as close to the Southwest steamboat landing as possible to accommodate badly wounded soldiers from the Virginia war front. (LOC.)

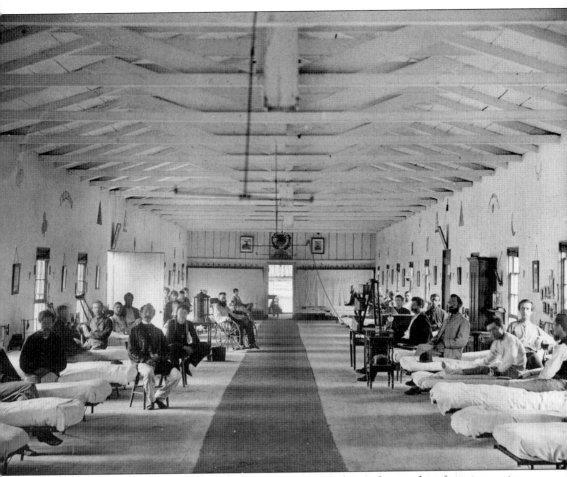

Each of the medical wards of the Armory Square Hospital was designed to function as its own self-contained unit with resident doctors, volunteer nurses, and orderlies. Nurses were also expected to keep up morale among morbidly wounded soldiers and recent amputees by providing piano music and games during the evening hours. Nurse Amanda Akin Stearns's diary of a ward nicknamed "The Chateau" was published in 1909 in a tome entitled *The Lady Nurse of Ward E.* (LOC.)

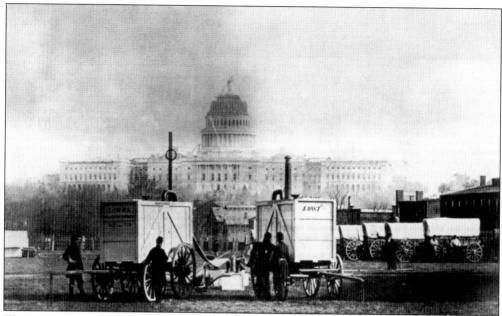

These gas generators for balloons and other apparatus were used by the Army Aeronautic Corps to survey Confederate troop movement across the Potomac, and was launched from the Mall in 1863. To the right are a group of structures along Maine Avenue, SW, now part of the National Mall. (NA.)

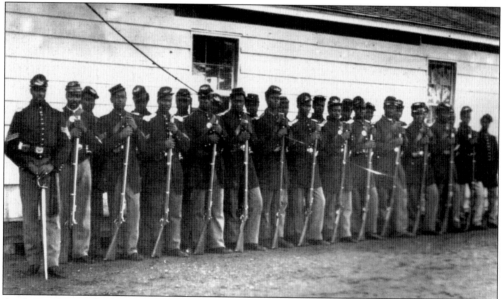

Anthony Bowen had been born into slavery in 1809 on the Maryland plantation owned by William Bradley and remarkably obtained an education and leadership qualities that allowed him to be able to purchase his own freedom in 1830. In 1853, he established a YMCA for blacks in Washington, only a year after his white counterparts. During the Civil War, Bowen, the Reverend John E. Cook, and Rev. Henry M. Turner recruited these black soldiers from Washington to fight for the Union, which eventually led to the U.S. Colored Troops arriving at the Seventh Street wharf at the war's end to the well-documented cheers of well wishers. (LOC.)

The Army Medical Museum was designed by Adolph Cluss and was built in 1886 on the site of what is today the Hirshhorn Museum and Sculpture Garden at Independence Avenue and Seventh Street. It was founded earlier, in 1862, by Brig. Gen. Alexander Hammond, and its mostly gruesome collection was moved here in 1887 from Ford's Theater. The building was demolished in 1969. (LOC.)

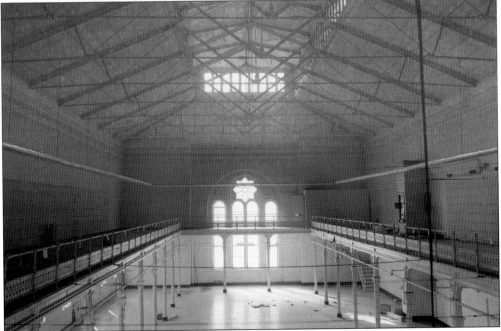

The interior exhibition space of the Army Medical Museum included this large east-wing gallery. Among the most popular exhibits were those surrounding the Civil War, with the fragments of President Lincoln's skull and assassinated Pres. James A. Garfield's vertebrae, along with rows of organs, amputated limbs, and wounds carefully stored in jars filled with formaldehyde. (LOC.)

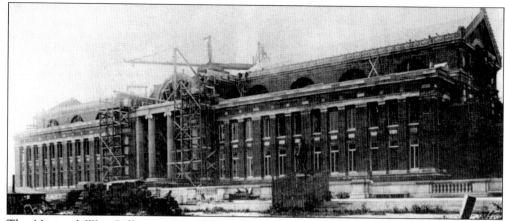

The National War College serves all branches of the military despite being located on an army base. Formed just after World War II, the experience from that conflict showed that the complexity of planning and conducting global war plus joint and combined military operations required officers and civilians in government, inter-agencies, industry, and non-governmental organizations to be thoroughly familiar with each other's roles, functions, and missions. They also needed the skills to operate comfortably at levels in which key national security and strategy decisions would be made in peace and war. (LOC.)

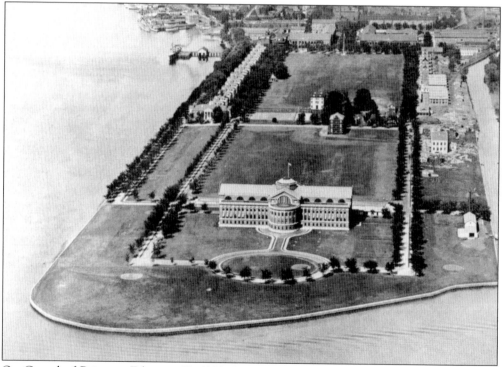

On Greenleaf Point on February 21, 1903, Pres. Theodore Roosevelt laid the cornerstone to the main building that now bears his name; it was home to the Army War College (1903–1917, 1919–1940), War Plans Division, War Department General Staff, Selective Service System Headquarters and Headquarters for the U.S. Army Ground Forces (all successively during World War II) before the creation of the National War College in 1946. It continues to serve in that capacity today. James Creek can be seen at right. (LOC.)

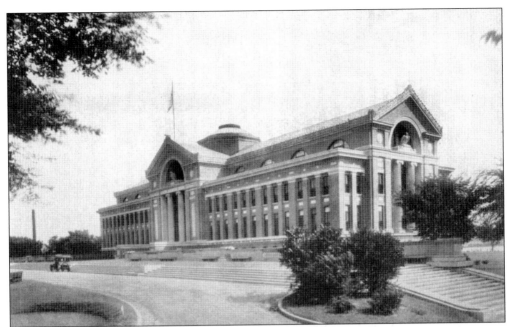

Fort McNair is the oldest active army post in existence today. To date, over 7,500 students have graduated from the National War College since its opening in 1946. (NA.)

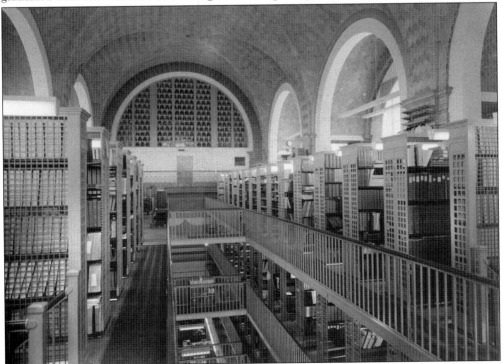

Opening in 1907 as the Army War College and later known as the National War College, seen here is the vast library located inside the barrel-vaulted roof of the structure. It had originally been proposed by Secretary of State Elihu Root in 1899 and was constructed between 1903 and 1907. (LOC.)

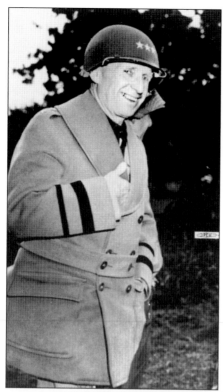

Fort McNair is named after Lt. Gen. Lesley J. NcNair (1883–1944), photographed here in 1944. He served as the first commander of the army ground forces, which were created in a major reorganization of the army in March 1942. The army ground forces became responsible for the organization, training, and equipping of all army units other than the air corps. McNair campaigned tirelessly to reduce overhead in U.S. divisions, insisting on as much streamlining as possible. He was accidentally killed by U.S. bombs while observing Operation COBRA on July 25, 1944. (LOC.)

Even the golf course at the National War College on Fort Leslie J. McNair in southwest Washington was targeted for temporary housing in World War II, and in this case, it was surveyed and found to be suitable for 5,000 housing units in the spring of 1941. (MLK.)

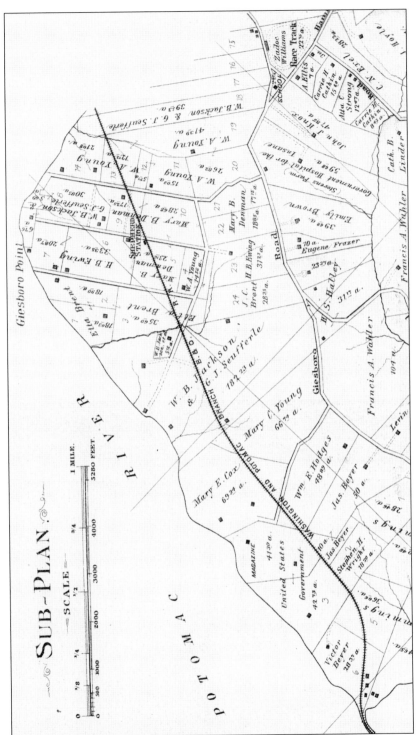

This 1887 Hopkins map of the southernmost section of Southwest shows the landowners and large parcels that has been incorporated into Bolling Air Force Base and other Department of Defense installations. (Author's Collection.)

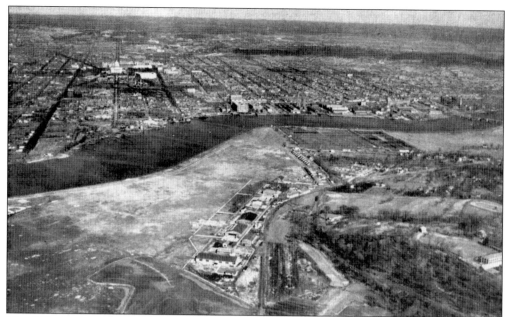

The U.S. Army transferred a large plot of ground known as the Anacostia Flats to its aviation department, the Signal Corps, on October 2, 1917. The site was enlarged by infill and in 1920 was renamed Bolling Field after Col. Raynal C. Bolling, who had been killed in action two years prior. The navy and other Department of Defense installations have jointly shared portions of the 320-acre site since 1917. Today Bolling Air Force Base mainly houses Pentagon employees and is oddly one of the few air force bases without a runway for aircraft. (LOC.)

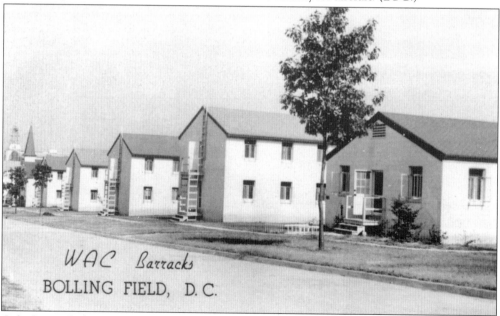

Col. Oveta Culp Hobby had been brought to Washington in September 1941 to head the Women's Auxiliary Army Corps (WAAC), which would grow to 10,000 strong in its first year. These rows of temporary barracks were built for the exclusive use of women enlisted in the WAAC and were located at Bolling Field, which later became Bolling Air Force Base. (MLK.)

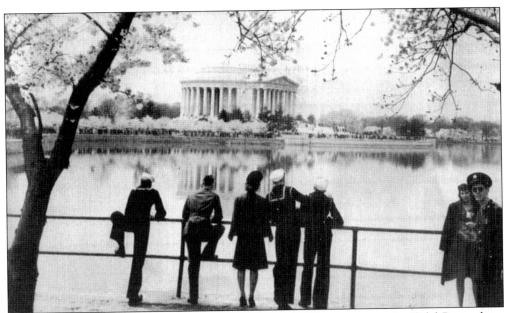

These sailors were photographed enjoying the Japanese cherry trees on the Tidal Basin about 1943. Four of the famous trees had been vandalized following the Japanese attack on Pearl Harbor, prompting the National Park Service to take additional precautions in security. The Jefferson Memorial, seen in the background, was the only memorial dedicated during the war, and was dedicated by President Roosevelt on April 13, 1943, albeit with a plaster statue of Jefferson by sculptor Rudolph Evans inside the rotunda, which stood in place until a bronze replacement could be installed following wartime restrictions on metal. (NA.)

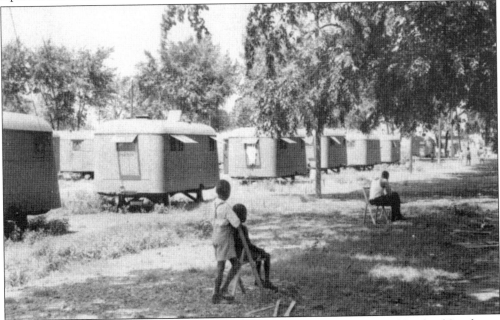

During the early stages of World War II, trailer parks were set up in the parklands of Southwest by the federal government beginning in 1943 to house relocatees from the necessary expansion of the navy yard. (DCHCD.)

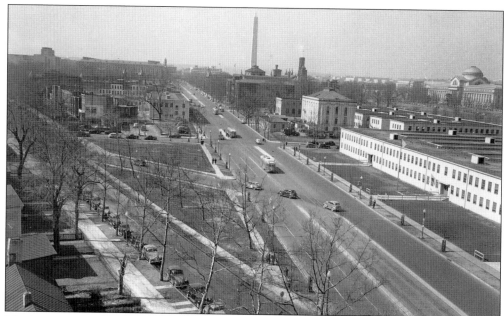

The intersection of Maryland Avenue and Independence Avenue is seen here in 1945 looking west. World War II temporary buildings can be seen on the right, across the street from the rooftops of old houses that were subsequently razed for new construction of government buildings. The large white building beyond the temporaries is the Washington Arsenal. (Photograph courtesy District Department of Transportation Archives, [DDOT].)

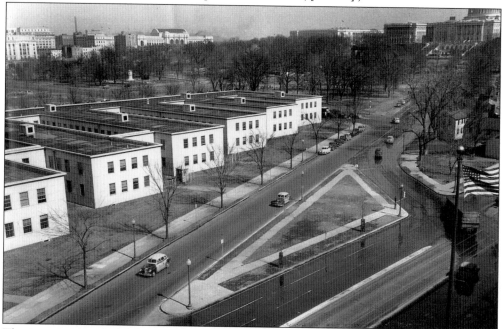

The intersection of Maryland Avenue and Independence Avenue is seen in this photograph from March 1945 looking east. World War II temporaries are shown at left, along with a portion of U.S. Capitol Building in the background. The intersection of the east spur roadway is called a channelization and is used to separate traffic. (Photograph courtesy DDOT.)

Three

THE WATERFRONT

Perhaps most synonymous with the Southwest community throughout its history has been the waterfront, having been lined with piers and continually used since the early 19th century. Steamboats began operation in 1815 and could be seen docking there until 1957. Their passengers were mainly travelers connecting to northern and southern railways and, in later years, to Washington's many segregated amusement parks located down river in Maryland and Virginia.

The promise and hope of a deep-water port was short lived, however, as tidal and current fluctuations made the waterfront only accessible to smaller craft early in its history. Soil erosion of lands located upstream contributed to the silt deposits in the river after the Civil War, when the Southwest waterfront became a market center for Washingtonians seeking seafood and farm produce shipped in from points south. Makeshift shanties and shacks were replaced in 1918 by the Municipal Fish Market to attempt a more civil shopping environment for city residents from afar.

Much of the dredging of the Potomac River over the years resulted in newly created land first called Potomac Park in the 1890s and today known as Hains Point. A public beach was formed on the southern side of the National Mall during World War I, long before the Jefferson and Lincoln Memorials were built on filled land. The segregated beach was for white residents only and was often the site of bathing suit contests in the liberated 1920s. Over the years, many plans called for the redevelopment of the waterfront, populated by houseboats during the World War II housing shortage, and it was not until the 1960s that it was reconfigured for tourist boats, a small fish market, and a public promenade used by the new residents of Southwest that emerged following redevelopment.

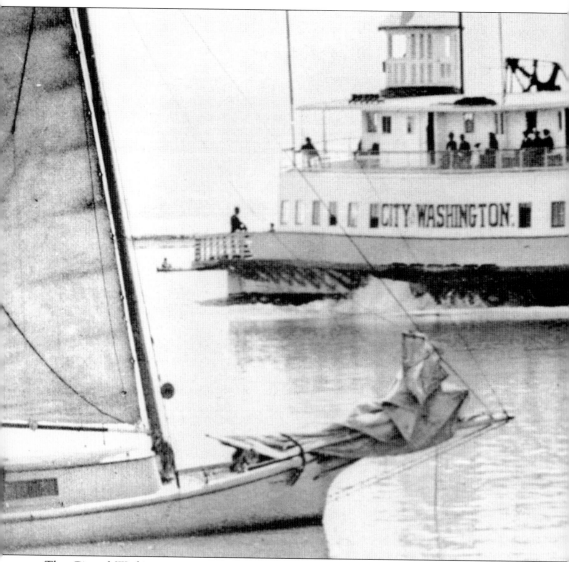

The *City of Washington* was just one of hundreds of steamboats to traverse the Potomac beginning in 1815. Many steamers, such as the *River Queen*, later carried city residents from Southwest to the Marshall Hall amusement park, located in Virginia. The Washington Park amusement center was developed for black Washingtonians by the city's first black millionaire, Lewis Jefferson, who began the Independent Steam Boat and Barge Company in 1900. The last steamer to operate on the river ceased service in 1957. (LOC.)

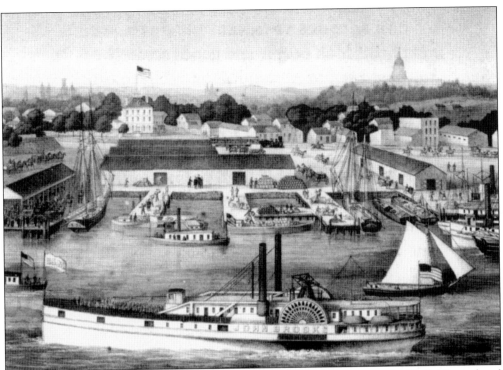

The Sixth Street wharf is depicted in this 1863 illustration, busy with Civil War–related activity. Seen in the background flying the American flag is the c. 1794 Thomas Law house, then operated as the Mount Vernon Hotel. (LOC.)

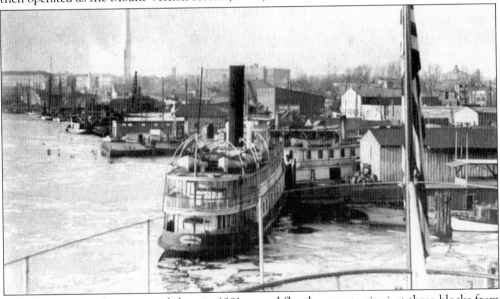

A harsh winter and unexpected thaw in 1881 caused flood waters to rise just three blocks from the White House, calling attention to the need for better dredging in the Potomac. Maj. Peter C. Hains of the Army Corps of Engineers was ordered by Congress to dredge the channel, depositing the silt in the low marsh to provide protection for the Southwest wharves. The newly formed land known as Hains Point now bears his name. (LOC.)

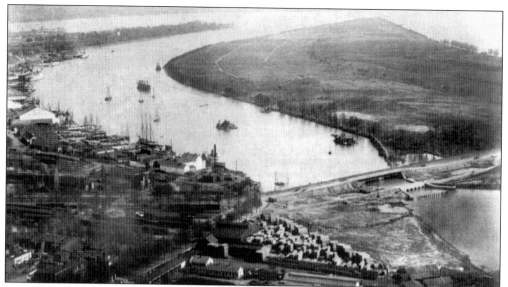

This early view of Southwest shows the newly created East Potomac Park, now known more commonly as Hains Point. The river's commercial use declined after the Civil War, as land was stripped of trees upstream, causing soil erosion that quickly filled the riverbed. (LOC.)

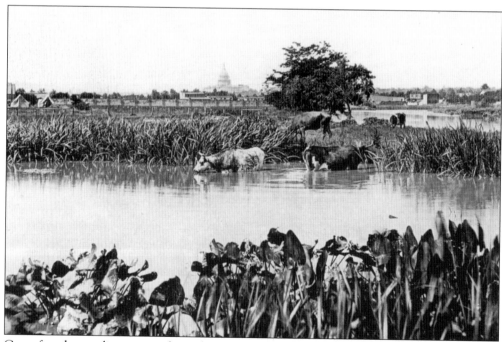

Cows found a cooling respite from the summer heat by grazing along the Anacostia River Marshes, which were prone to flooding when this image was taken about 1890. The rural nature of the waterfront was later filled in to create land surrounding the Tidal Basin and Jefferson Memorial. (Photograph by John Hiller, NA.)

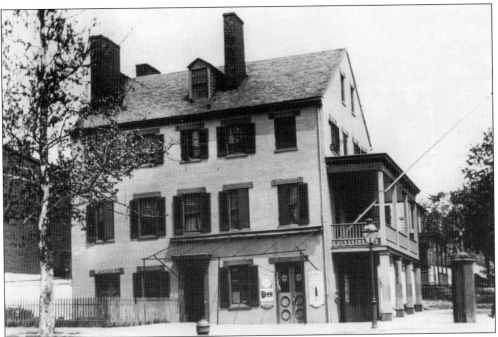

This image, taken about 1900, shows a former residential structure from the early 19th century that has been converted into a tavern hotel complete with pool room that no doubt catered to visiting seamen and dock workers. It was located on the waterfront at Tenth Street and Water Street (now Maine Avenue). (HSW.)

This large oyster boat, seen tied up at the fish wharf in 1915, is one of dozens of such boats that supplied the demand of such well-known city restaurants as Harvey's on Connecticut Avenue. Harvey's was known to have a huge pile of oyster shells outside its door as its many diners shucked the delicacy. (MLK.)

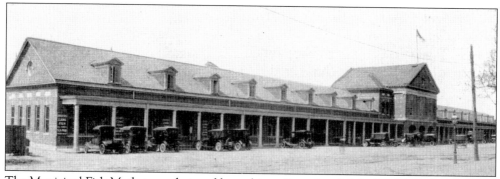

The Municipal Fish Market was designed by architect Snowden Ashford and built beginning in 1916 along Maine Avenue between Eleventh and Twelfth Streets. It was constructed to replace what was then considered an unsanitary row of individual fish markets. (LOC.)

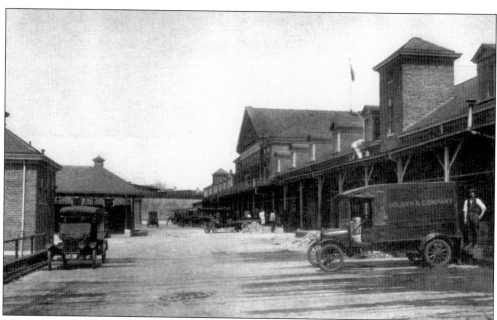

The Municipal Fish Market contained 24 fish stalls and administration offices in the colonnaded building, including the Department of Weights, Measures, and Markets. Seafood dinners were often served by the merchants on the balconies facing the waterfront and the four large wharves that extended into the Washington channel. (LOC.)

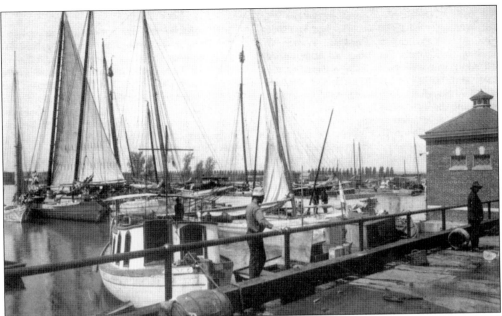

Boats, seen here at the Municipal Fish Market on Maine Avenue about 1918, often arrived before dawn with their daily catch of fish, oysters, crabs, and clams. (LOC.)

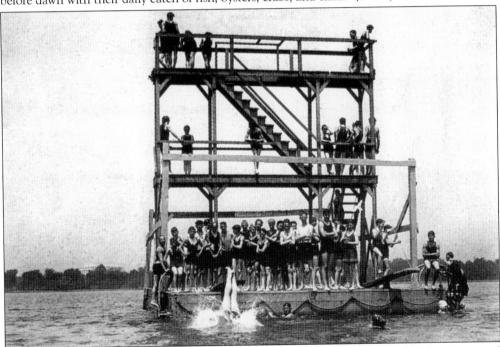

Long before the Jefferson Memorial and the Tidal basin was created, a public beach opened in 1917 on that location but for white swimmers only. The city's recreation facilities remained segregated until the late 1950s, although tennis and golf facilities were opened to black residents by the National Park Service about 1940. This large float was pictured on June 2, 1923. The beach and bathhouse closed in 1925 due to a chronic problem with "waterborne debris," and the Jefferson Memorial was eventually built on its site between 1939 and 1942. (LOC.)

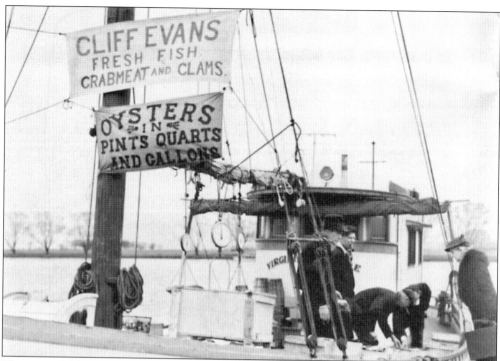

The owner of the *Virginia Estelle*, Cliff Evans, proudly displays his oyster catch at the waterfront, available in containers ranging in size from pints to gallons, almost unheard of today. (LOC.)

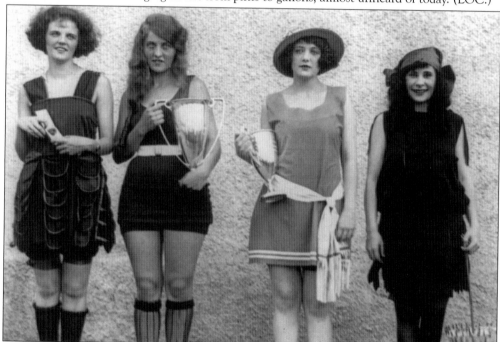

The winners of the 1922 bathing suit contest proudly hold their prizes at the Tidal Basin Beach. Pictured from left to right are Gay Gatley, Eva Fridell, Anna Neibel, and Iola Swinnerton. The Tidal Basin beach had been built by the Army Corps of Engineers beginning in 1916. (LOC.)

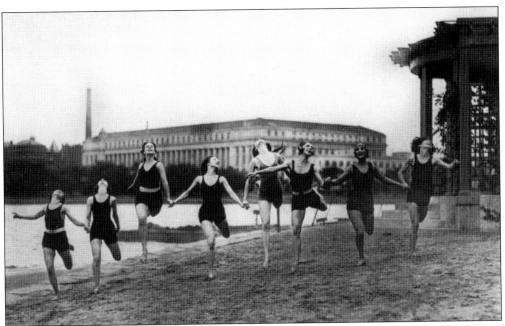

These bathing beauties were photographed in 1922 sharing a swift run toward the Tidal Basin Beach. The large building in the background is the Bureau of Printing and Engraving, built in 1914. (LOC.)

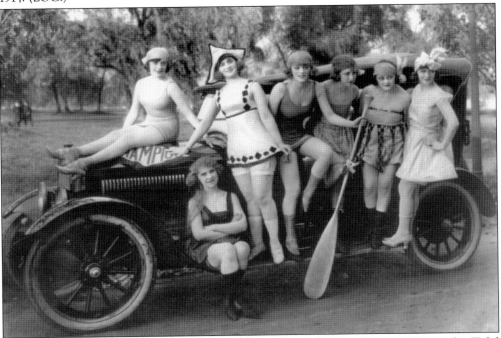

These beautiful girls in their bathing suits were photographed in the mid-1920s at the Tidal Basin Beach as part of a promotional campaign by Seven Mack Sennett, a film entrepreneur soon nicknamed "The Master of Slapstick Comedy." He formed Keystone Company and Studios in 1912 and soon became the leading producer of fast-moving, slapstick, and comic character films. (LOC.)

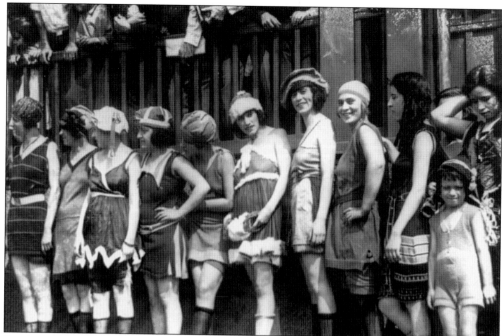

Ready for a bathing suit contest in the 1920s, these girls line up at the Tidal Basin Beach to be judged. The injustice of the segregated beach led to an effort headed by the superintendent of public grounds, Lt. Col. C. O. Sherrill, to submit four locations for a black beach, one of which was proposed to be just east of the War College. The African American community, however, argued that a separate beach would be submitting to second-class citizenship, and they unsuccessfully attempted to integrate the Tidal Basin Beach. (LOC.)

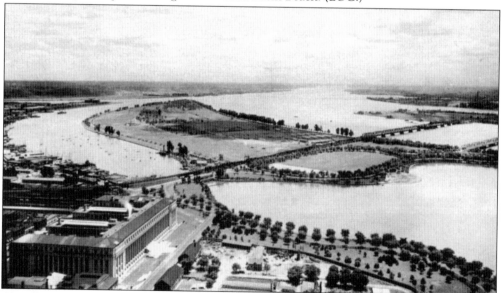

The enormity of East and West Potomac Park and the Tidal basin can be seen in this photograph taken from the Washington Monument about 1920. The Bureau of Printing and Engraving can be seen at left and the site of the future Jefferson Memorial at right on the north side of the newly formed island. (LOC.)

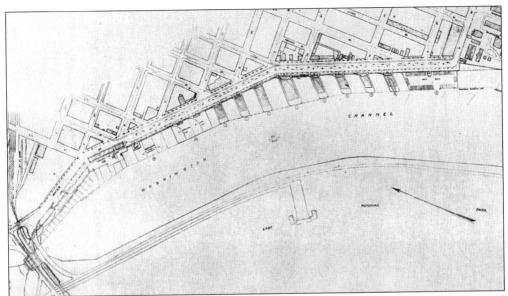

This redevelopment plan for the waterfront was delineated by the U.S. Engineer Office and submitted to Congress in 1929. It called for the creation of a 160-foot-wide Water Street and replacement of all of the existing structures with the exception of the Municipal Fish Wharf. Six large wharves of "modified Colonial design" were proposed, and railroad piers and slips were discouraged. It was never realized. (LOC.)

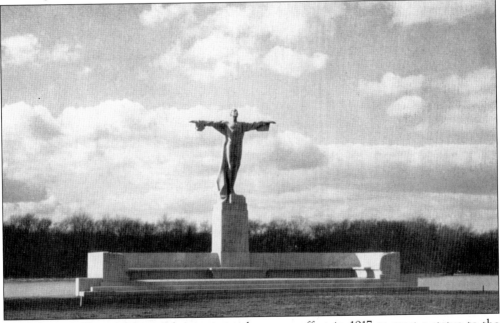

The Women's Titanic Memorial Association began an effort in 1917 to erect a statue to the 1,517 victims of the Titanic sinking, and their plans were finally unveiled on May 26, 1931, by Mrs. William Howard Taft at its location in Waterside Park at P Street and Fort McNair. Henry Bacon served as the architect, and the sculpture was executed by Gertrude Vanderbilt Whitney in pink granite. The Titanic Society, a group limited to just 20 men, lays a wreath on the site every anniversary of the sinking on April 15, 1912. (LOC.)

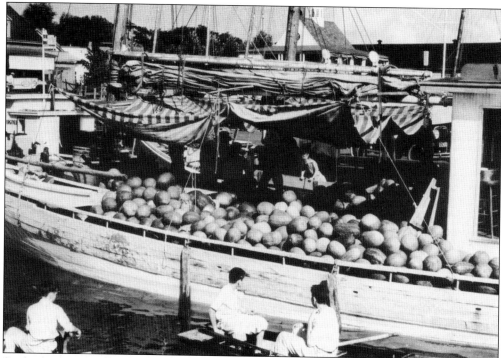

Seafood was not the only food to be found by city residents exploring the waterfront; farmers would routinely bring seasonal fruits and vegetables to the piers by boat directly from their farms in lower Virginia and Maryland. This watermelon boat was photographed tempting onlookers in 1933. (LOC.)

Photographer Gordon Parks took this image of the waterfront fruit market in November 1942. (U.S. Office of War Information, LOC.)

Many D.C. residents solved the problem of finding suitable housing during the World War II years by purchasing or renting houseboats as their homes. Temporarily anchored due to gas rationing, hundreds of such boats lined the city's harbors. Seen here in the summer of 1943 is the director of the Government Girls School for Self Improvement, Mrs. John Paul Gensener, and her son, John. (MLK.)

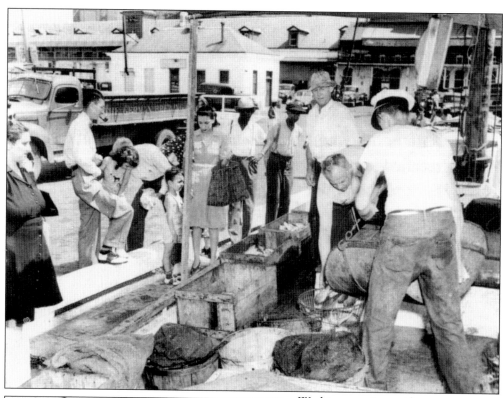

Washington city residents are seen here in 1945 buying their fresh soft-shell crabs and fish directly off this boat docked at the Southwest waterfront. (MLK.)

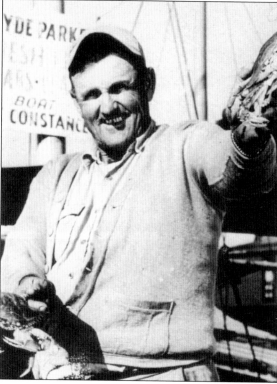

Large, fresh, soft-shell crabs were almost always available direct from the boat along the waterfront docks. Here captain Clyde Parker shows off his catch in 1959. (MLK.)

Four

THE

FEDERAL GOVERNMENT

Outside of the military, the federal government has had a presence in Southwest since construction began in 1847 on the Smithsonian Castle, designed by James Renwick. It was joined on the National Mall shortly thereafter by the U.S. Botanical Gardens, relocated in 1859. Perhaps the first federal office building built in Southwest was the humble beginnings of the Agricultural Department in 1868, when 72 employees moved into an Adolph Cluss–designed building on the department's current site along Independence Avenue and Fourteenth Street.

In the Victorian era, the Smithsonian's Arts and Industries building was constructed in Southwest in 1879, followed the next year by the Bureau of Printing and Engraving, both of whom remain there to this day.

Residential buildings were purchased and plans were made to protect the vista of the National Mall by surrounding it with federal buildings in 1901, signaling the first phase of destruction of the Southwest community by the government. By the 1920s, traffic gridlock and new buildings such as the expansion of the Department of Agriculture, Printing and Engraving, and later the Health and Human Services Building all contributed to the growing federal ownership of the area.

Newly conceptualized federal buildings were built under a program by Pres. John F. Kennedy to modernize the government workplace, and the area attracted top architects eager to show off their then modern designs for large-scale cement buildings still found along the corridor today. Many of the buildings featured designs popular before their time, and their building dates in the 1960s will perhaps surprise many fellow residents and visitors alike.

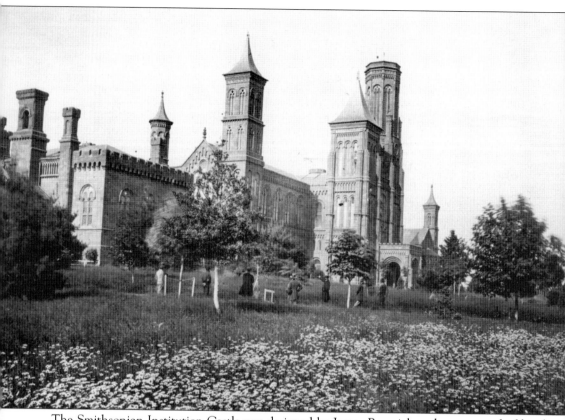

The Smithsonian Institution Castle was designed by James Renwick and constructed of local sandstone between 1847 and 1855. It is located along Jefferson Drive between Ninth and Twelfth Streets and is considered one of the finest Gothic-style structures in the United States. The Smithsonian was made possible through the bequeathal of $550,000 by British scientist James Smithson. The photograph is by A. J. Russell. (LOC.)

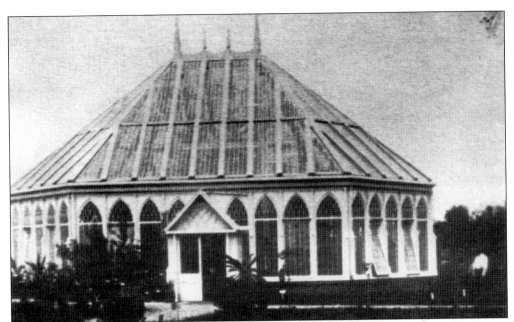

The Botanical Garden had its origins on the east end of the Mall beginning in 1820, when it was founded by the Columbia Institute for the Promotion of Arts and Sciences. It was moved to the Patent Office Building in the northwest quadrant in 1842 but returned to Southwest with the 1859 construction of this octagonal greenhouse designed by Thomas U. Walter (1804–1887). (Architect of the Capitol.)

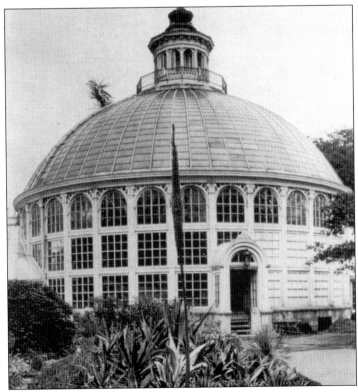

The Botanical Garden was significantly expanded in 1867 by the architect of the capitol, Edward Clark, who incorporated the original building into a 300-foot-long structure that cost an impressive $45,000. It was photographed by Gen. Montgomery C. Meigs. The complex was razed in 1931 for the construction of the present-day Botanical Garden complex, positioned for unobstructed views of the Mall. (LOC.)

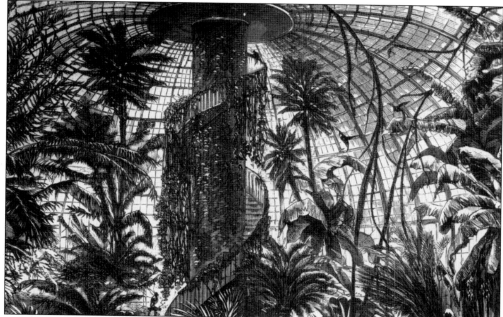

The central portion of the expanded 1867 design was the Palm House, 60 feet in diameter and 55 feet high. It featured a central brick chimney that both supported the roof and provided a circular stair for visitors to view the 20 species of palms, 60 varieties of orchids, ferns, and other exotic plants. Its interior was illustrated for the June 26, 1869, edition of *Harper's Weekly*. (Author's Collection.)

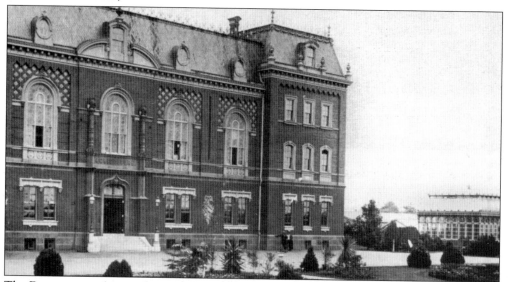

The Department of Agriculture can trace its roots to Southwest Washington in 1868, when its 72 employees first occupied this new headquarters building located just north of the present-day Agriculture Building at Independence Avenue and Fourteenth Street. It was designed by German architect Adolph Cluss and occupied a site that then allowed for extensive gardens, greenhouses, and experimental crops. The gardens were overseen by Scotland native William Saunders, a prolific writer and researcher whose noted work includes the invention of the Washington naval orange that later was used to begin the California orange industry. (NA.)

The interior of the original $100,000 agriculture building featured offices for its employees and exhibition space for federally collected specimens of seeds, plants, agricultural tools, and produce, seen here. (HSW.)

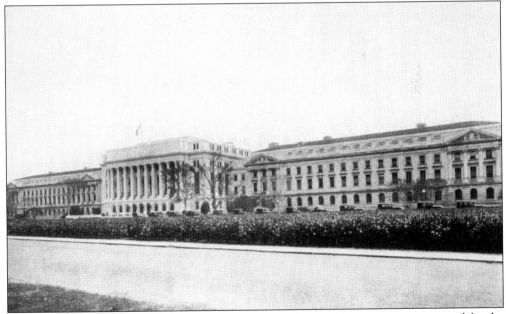

Most of the greenhouses surrounding the original Agricultural Department were razed for the 1908 construction of two wings of the present-day department. The main building remained, however, until the 1930 completion of the central administration building, executed in Georgian marble. The combined building housed 5,000 employees and consolidated 57 independent offices and laboratories located throughout Washington. (LOC.)

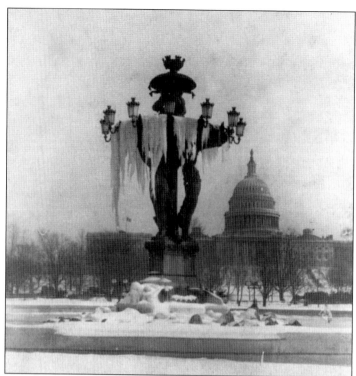

A major fixture on the Mall in Southwest Washington since 1877 has been the Bartholdi Fountain, seen here with its water frozen in place about 1890. Congress authorized its purchase that year from its location at the Philadelphia Centennial Exposition, and it was placed on the grounds of the Botanical Garden. It was moved to its present location at Independence Avenue and First Street in 1931. (LOC.)

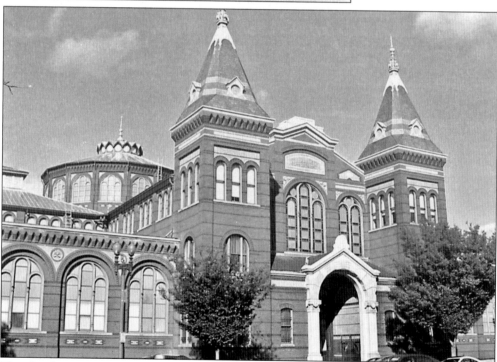

The Smithsonian's Arts and Industries Building has stood at 900 Jefferson Drive since its construction in 1879. It was designed by the firm of Cluss and Schulze and is often noted as one of the government's most inexpensively built structures, costing less than $3 per square foot. (MLK.)

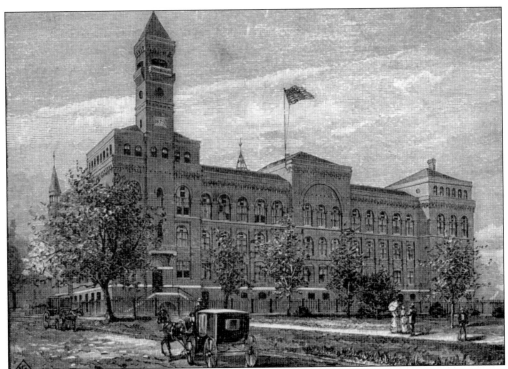

The original building of the U.S. Bureau of Printing and Engraving at Fourteenth and B Streets was built in 1880 and produced approximately $5 million worth of small bank notes every 28 days from its 250 presses and 500 printers. (*Picturesque Washington*, 1887, Author's Collection.)

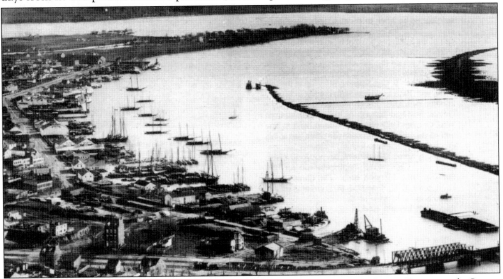

This photograph, taken from the Washington Monument in 1885, shows Fourteenth Street in the foreground leading to the Long Bridge over the Potomac. The former location of the Washington Barracks and Washington Penitentiary appears on the peninsula in the background. Today this is the site of Fort McNair and the War College. Dredging operations seen in the channel are being conducted by the Army Corps of Engineers, with silt deposited on the right to eventually form Hains Point. (LOC.)

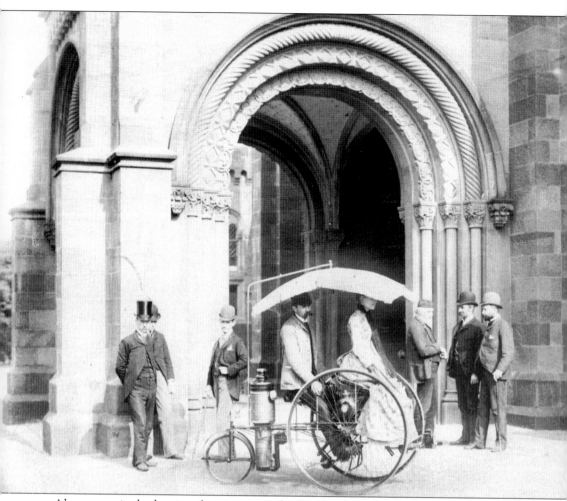

Always seemingly the site of innovations, the Smithsonian Castle entrance was the backdrop of this 1886 photograph showing the steam-powered tricycle invented and driven by Lucius D. Copeland. (Smithsonian.)

One of the more unusual structures to occupy the grounds of the Agriculture Department in Southwest Washington from 1893 to 1932 was the General Nobel Redwood tree house—a giant sequoia cut from the General Grant National Park in California for the 1892 World's Columbian Exposition in Chicago. It took four lumbermen a week to cut the 26-foot-diameter trunk. (LOC.)

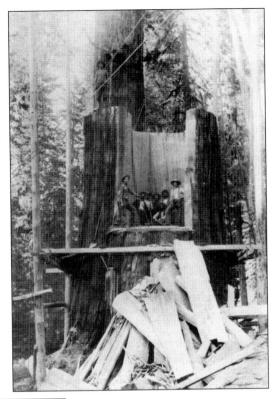

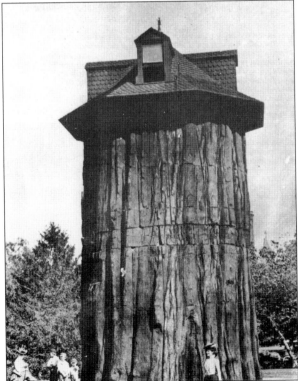

The base portion of the tree was covered with a roof made of redwood shingles for weatherproofing and outfitted with an interior staircase for exploration by curious visitors to the Mall. The tree was named after Civil War general John Willock Noble, who later advocated forest preservation of lands owned by the federal government. The spectacular tree house was removed in 1932 and stored for future use at the Pentagon site but instead was sadly burned in 1940. (LOC.)

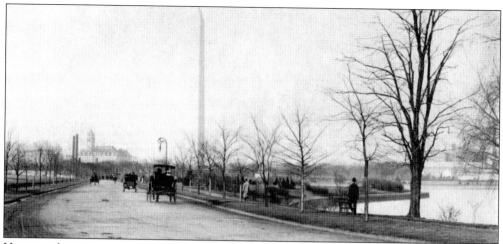

Horses and carriages carry passengers along the Tidal Basin in this idyllic setting photographed about 1900. (NA.)

The baron site of the future Lincoln Memorial is seen here in 1901; half of the memorial is technically in Southwest. When it was built in 1922 to the designs of Henry Bacon and sculptor Daniel Chester French, it was built atop a raised foundation nearly two stories high, and the ground was filled in around it to create the illusion that it sits atop a small hill. (LOC.)

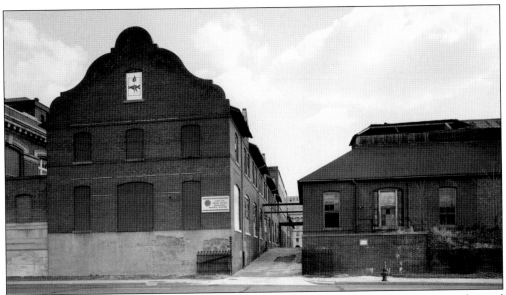

Four different architects designed what was known as the Auditor's Complex, once located on Independence Avenue between Fourteenth and Fifteenth Streets. The buildings housed laundry, stables, and support functions for the Bureau of Printing and Engraving. It was designed in stages beginning in 1902. The laundry was a critical function in the printing of money due to the need to separate the sheets of paper with scrupulously clean cloths to maintain a proper degree of moisture. The building were given to the Holocaust Memorial Council in 1981 as a potential site for their planned museum. (LOC.)

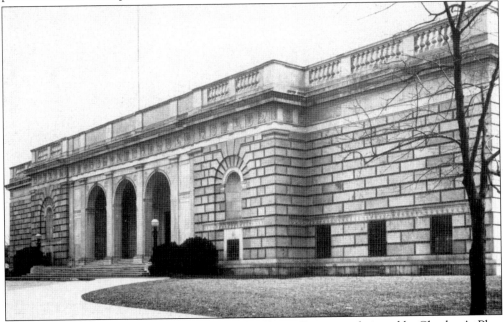

The Freer Gallery of Art at Twelfth Street and Jefferson Drive was designed by Charles A. Platt and was built in 1923. Its collection was donated by Charles Land Freer, who had made a fortune manufacturing railroad cars. Freer did not stop there, however; he hired the architect, built the building, and donated the entire package to the United States. (LOC.)

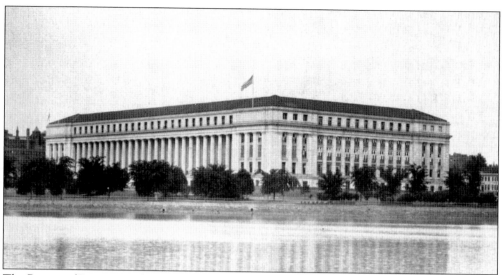

The Bureau of Printing and Engraving's second building is seen here from the Tidal Basin about 1928. Built of limestone, it provided over 10 acres of floor space and, in addition to printing paper money with a face value of $15 trillion in 1930 alone, the bureau then also printed postage stamps, revenue stamps, bonds, liquor prescriptions, commissions, warrants, and other engraved printing needs of the government. (LOC.)

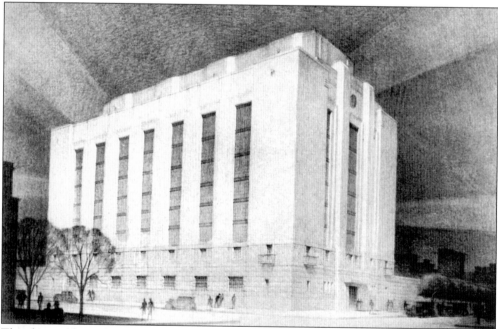

This drawing by architect Paul Crete of his design for the Central Heating Plant was done just prior to the building's completion in 1934 within the block surrounded by C and D Streets and Twelfth and Thirteenth Streets. Adjacent to the Pennsylvania Railroad tracks from which coal was delivered, the building provided steam heat to all of the governmental buildings located on the south side of the mall via a series of underground tunnels. A limestone panel at the Thirteenth Street entrance depicts a generator, boiler safety valve, fan, and heat exchanger, while a panel at the central window depicts coal furnaces, boilers, and steam pipes. (LOC.)

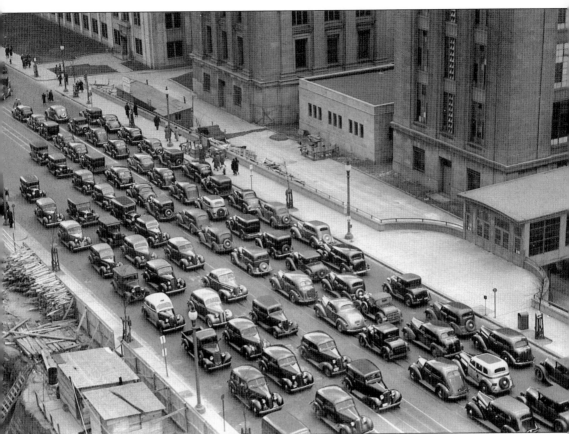

At the beginning of the 20th century, the growing number of governmental office buildings in upper Southwest, along with a growing American obsession with automobiles, led to the inevitable: traffic. Gridlock pictured about 1935 is seen here stopped on Fourteenth Street in front of the Bureau of Printing and Engraving. The construction site at left is the expansion of the Department of Agriculture. (Photograph courtesy DDOT.)

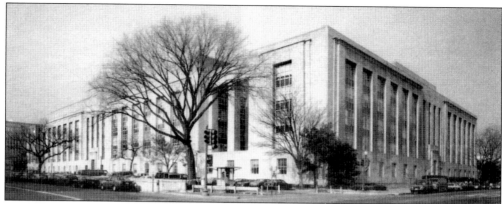

The Health and Human Services Building at Independence Avenue and C Street between Third and Fourth Streets was built between 1939 and 1941 to the designs of the office of the supervising architect. Composed of two companion buildings to house two bureaus serving federal retirement programs, both feature Egyptian architectural elements. Sculptor Robert Kittredge created over-door panels on the southern building that feature railroad workers. (LOC.)

This view looking east on Independence Avenue from Fourteenth Street in 1945 shows the recent completion of the pedestrian bridges linking the Department of Agriculture buildings that are now familiar landmarks to tourists and residents alike. (Photograph courtesy DDOT.)

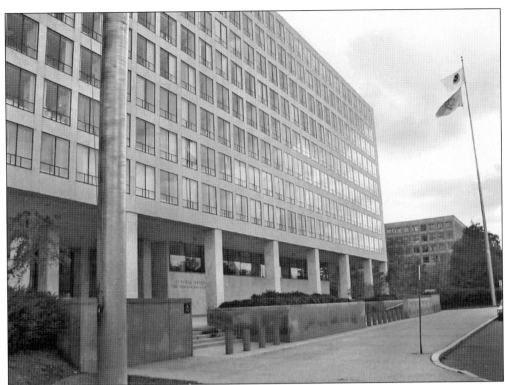

Few passersby would realize that this modern-looking structure at 800 Independence Avenue known as "Federal Office Building No. 10" was actually built in 1963. It was designed by the architectural firm of Holabird and Root to conform to Pres. John F. Kennedy's desire for improved and modern work space for federal employees. When built, it featured an innovative interior of movable walls to accommodate the ever-changing needs of offices and workstations. (Author's Collection.)

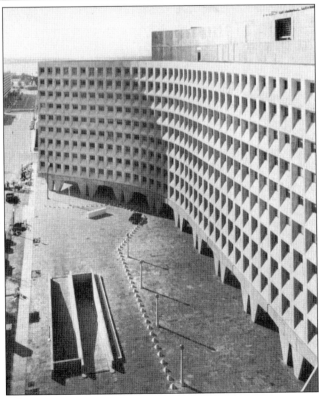

Modernist architect Marcel Breuer designed the Department of Housing and Urban Development, built in 1968, with his trademark windows deeply set into the façade. It is located at 451 Seventh Street. (LOC.)

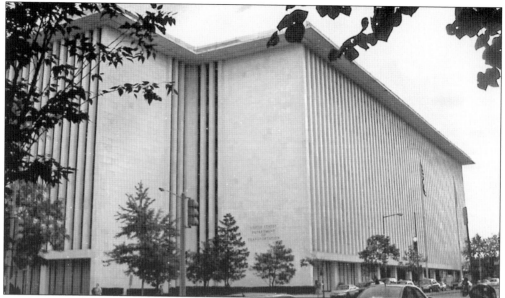

The U.S. Department of Transportation Building at Seventh and D Streets is another structure that many may think is far more recent than its 1969 construction date. It was designed by Edward Durell Stone as a speculative project built to be rented to the government for flexible office space. As a privately owned building, it lacked much of the monumental decorative elements but with the same Italian-quarried vertical marble bands found on Stone's Kennedy Center that was being built at the same time. (Author's Collection.)

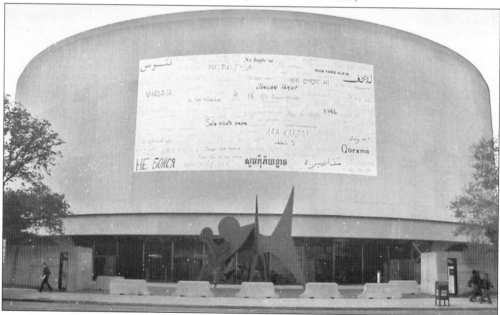

The Joseph H. Hirshhorn Museum and Sculpture Garden at Independence Avenue and Seventh Street was built in 1974 to the designs of the Skidmore, Owings, and Merrill. When it was being proposed, the secretary of the Smithsonian told the planning committee that if the building "was not controversial in almost every way, it would hardly qualify as a place to house contemporary art." His statement proved correct. (Author's Collection.)

Five

THE SOUTHWEST NEIGHBORHOOD 1870–1950

Like most large-city neighborhoods that have been home to a plethora of diverse ethnic and economic groups throughout time, Southwest is clearly no exception. The perception, however, is different even among longtime Washington residents, many of whom began with an inability to locate the vibrant community of residents they knew beyond the tourist-oriented waterfront. It was harder to comprehend its rich and diverse historical past both before and after the era of urban renewal changed it forever.

The largely African American community that was well-documented in the 1930s began with a diverse community of whites and blacks following the Civil War. They were employed in farming, governmental jobs from clerks to janitors, and the burgeoning dock work along the waterfront. Like most neighborhoods in Washington at the time, the housing stock supported poverty stricken inhabitants in the alleys and more wealthy occupants in some of the largest houses to be found in the city in the 1880s. The community was seemingly always diverse due to this difference in housing, with Italian, Jewish, German, and Greek immigrants mixing with blacks and whites that had been associated with the area for decades.

Fourth Street tended to serve as a basic racial barrier, but it was a commercial corridor that welcomed all races to its shops, taverns, and businesses owned by diverse merchants. The community was home to the D.C. Morgue and an incineration plant that burned dead animals found on city streets, but also was home to fine restaurants and early tourist steamboats traversing the Potomac. Like many other aging communities, however, Southwest began an architectural dilapidation of its infrastructure that led to the area being perceived as a slum.

Despite the physical conditions, the Southwest neighborhood was a close-knit community in which everyone seemed to know one another and, more importantly, kept a watch out for each other. Talk to anyone that grew up in Southwest, and they will tell you that if you ran into trouble on the way home from school, your parents often knew it by the time you arrived at home. Photographer Gordon Parks attempted to document this aspect in his remarkably rich photographs of the neighborhood from the 1940s, now housed as part of the Library of Congress collection.

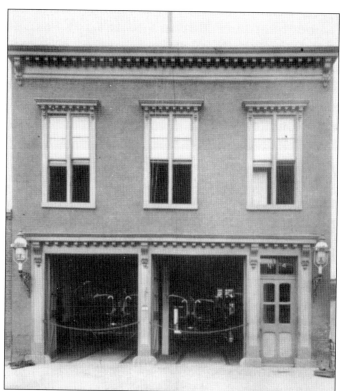

With the growing development of residences and businesses in Southwest, a firehouse was built to protect the community in 1869 on Virginia Avenue between Four-and-a-Half Street and Sixth Street, seen here. It was named the S. J. Bowen Company and was designated as the No. 4 Engine House. In January 1870, an ordinance made jobs at the D.C. Fire Department full-time paid positions. (Author's Collection.)

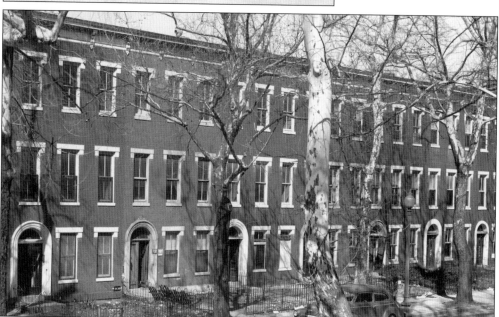

This elegant row of homes, located from 601 to 613 Sixth Street, was built in 1871 by lumber merchant Charles B. Church. They combined architectural elements popular 40 years earlier in other East Coast cities but updated with large brackets and window openings that were gaining popularity in Washington at the time, a testament to the owner's business and not to a hired architect. (LOC.)

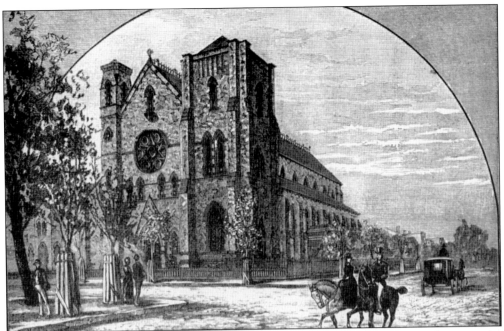

St. Dominic's Roman Catholic Church at Seventh and E Streets has been a central community gathering place since its dedication in 1875. Established in 1852, the Dominican parish survived a disastrous fire in 1885 and the widespread urban renewal demolition in the 1960s. It is well remembered by old Southwest residents for its festive summer carnivals open to all races and ages. (*Picturesque Washington*, 1887, Author's Collection.)

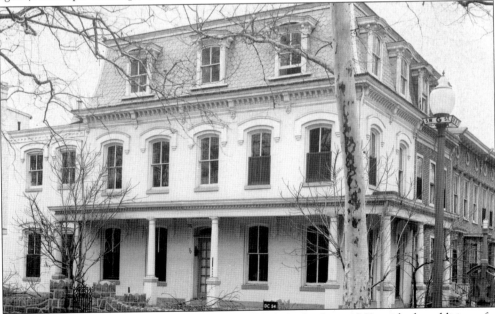

This house, once located at 601 G Street, was likely built about 1860, with the addition of a French mansard-style roof added later about 1875. It was still standing in 1958 when it was documented for the Historic American Buildings Survey, but it later fell victim to urban renewal plans. (LOC.)

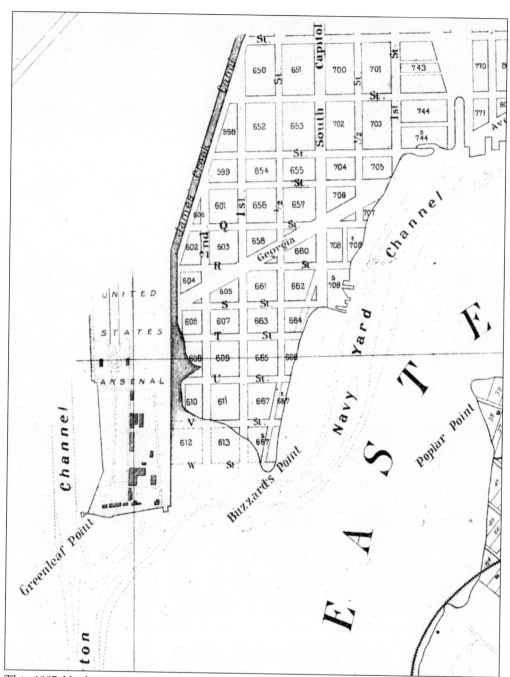

This 1887 Hopkins map shows the southern point of South Capitol Street and the current filling of land near Buzzards Point, where newly designated squares had already been enumerated despite the fact they were still underwater. Greenleaf Point can be seen on the Washington Arsenal site at left. (Author's Collection.)

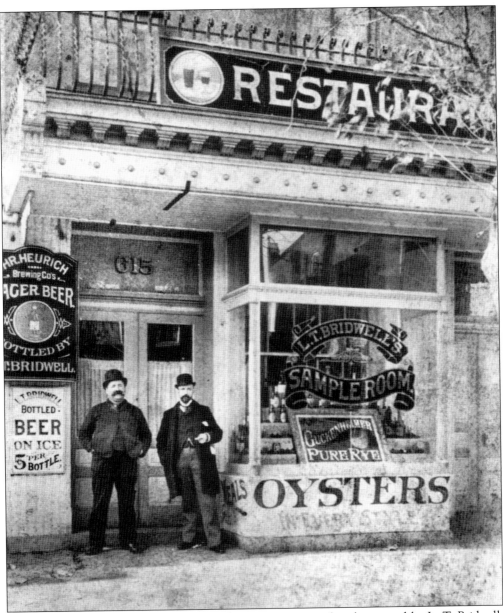

This saloon and oyster bar at 615 Seventh Street was owned and operated by L. T. Bridwell. Pictured here in 1890, it served locally brewed Heurich Lager beer bottled onsite for just 5¢ a bottle and oysters bought close by on the waterfront. (HSW.)

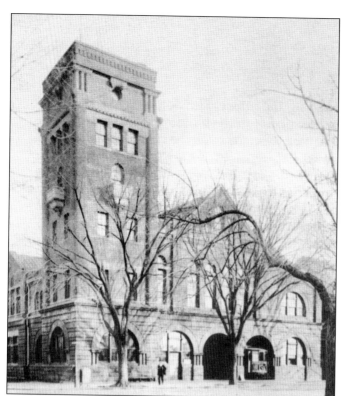

This impressive Romanesque Revival–style building for the Metropolitan Railroad Company was built as a combination powerhouse and car barn in 1892 at the northeast corner of P and Fourth Streets to the designs of architect John Brady. Its tower was damaged beyond repair in a 1896 hurricane. The building was razed by D.C. Transit owner O. Roy Chalk in 1962 to build Riverside Condominiums and Channel Square. (LOC.)

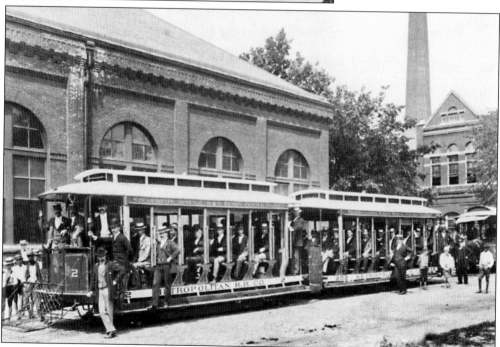

Electric streetcars of the Metropolitan Railroad can be seen here about 1895 at a carbarn at Fourth and P Streets. Trolley repair shops were located across the street, and Southwest residents used the system to get to and from work and various markets throughout the city. (MLK.)

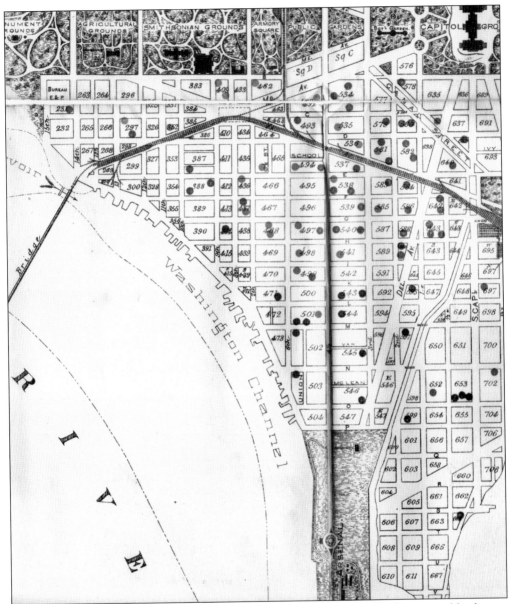

This map, produced by the D.C. Health Department in 1896, shows the location of fatal cases of consumption in the Southwest section—people who literally drank themselves to death. The light colored dots represented a single black person, while the darker dots represented a single white person. Eighty-two people in all met their death that year through the bottle. (Author's Collection.)

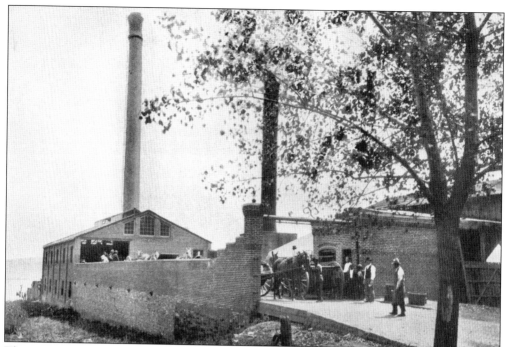

The Brown Garbage Crematory was built in 1895 at the foot of South Capitol Street on the corner of T Street. It burned coal to incinerate garbage and dead animals that arrived at the facility by boat or horse-drawn carts. (Author's Collection.)

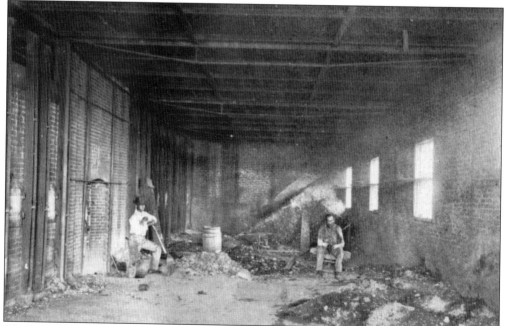

The D.C. Health Officer reported that the Brown Garbage Crematory burned 39 tons of garbage during its first year of operation beginning in March 1895. Incredibly it was also reported that a total of 4,846 dead animals were also cremated at the facility that year, an average of 20 per day. Seen here are workers sorting and storing ash inside the facility. (Author's Collection.)

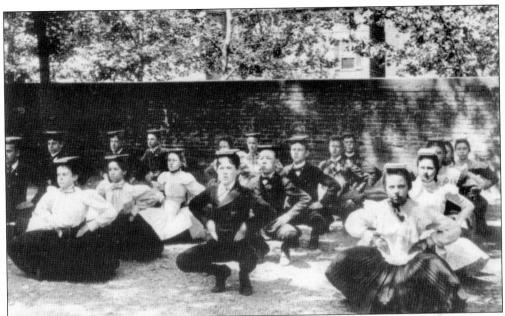

Before the 1954 Supreme Court ruling that called the "separate but equal" school policy unconstitutional, black and white residents attended different schools. White students are seen here at a unnamed Southwest school performing exercises with books on their heads in 1899. In 1954, with most of the area slatted for urban renewal or already razed, black students from Randall Junior High School joined their white counterparts without incident at the Jefferson Junior High School at 801 Seventh Street, which had been built in 1940. The diversity found in the neighborhood at the time contributed to a more gentle integration than in other parts of the city. (LOC.)

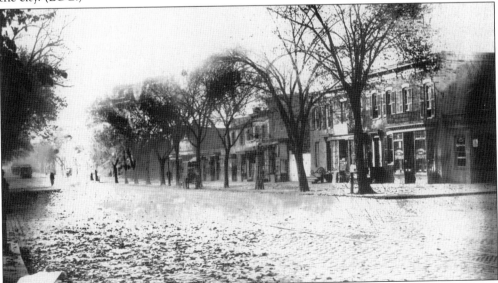

This image shows the old Four-and-a-Half Street (now Fourth Street), looking south from I Street about 1900. Fourth Street tended to be a racial dividing line, with whites living to the east and blacks to the west but coming together to shop and recreate in the middle. This commercial block was replaced by the Waterside Mall. (LOC.)

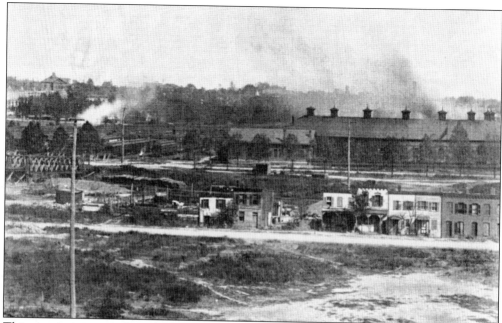

This rare image was taken about 1900 and shows Half Street in the foreground, just beyond the open field. Behind the row of small, wood-frame homes is the James Creek Canal, by then plagued with stagnant water, mosquitoes, and garbage. The large building on the right was the Baltimore and Potomac Railway Round House. (LOC.)

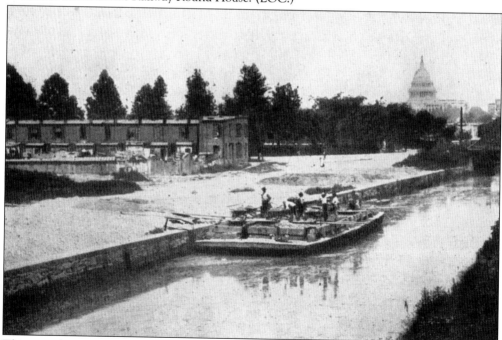

This rare photograph of the James Creek Canal was taken about 1900; the creek was described a few years later by author Charles Weller as a "notorious, malodorous, deadly . . . greasy, foully-effervescent, open sewer." It was then covered over as far south as G Street, SW, but was open to the south. An average of 10 people a year drowned in the open canal. (Author's Collection.)

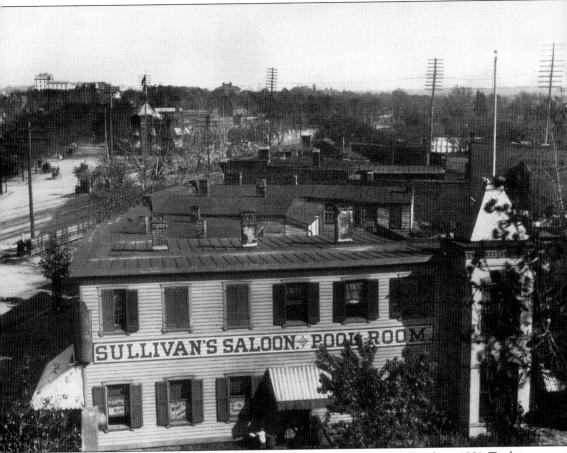

Sullivan's Saloon and Pool Room was once located at 104 E Street, seen here about 1901. To the left is Virginia Avenue and First Street. In the distance is the Dent School (with two chimneys) at Second and F Street, SE. The site of Sullivan's today is not recognizable at the intersection of the CSX Rail Line, Interstate 395, and the Southwest Freeway. (LOC.)

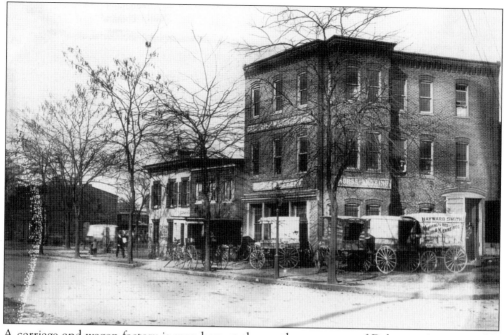

A carriage and wagon factory is seen here at the northwest corner of Delaware Avenue and E Street about 1900. Merchants from all across the city have apparently dropped off their various carriages for repairs. The block was torn down about 1907 for the construction of a raised railroad line that continues to operate Amtrak trains to this day. (LOC.)

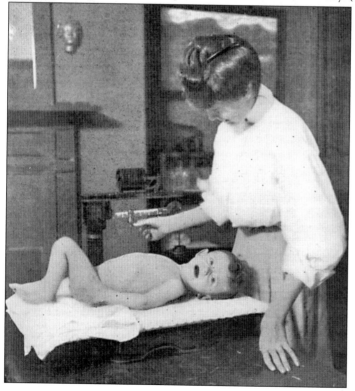

In 1901, Charles Weller and his wife, Eugenia Winston Weller, cofounded the Neighborhood House in the c. 1817 Lewis House at 456 N Street. It included a library, recreation facilities, and an infants and children's dispensary, seen here in 1908. Eugenia Weller served as its head resident until 1907. The institution moved to the Duncanson-Cranch House in 1904 when it was purchased by artist Alice Pike Barney, eventually occupying three of the four houses of Wheat Row. It moved to Sixteenth Street, NW, in 1960. (Author's Collection.)

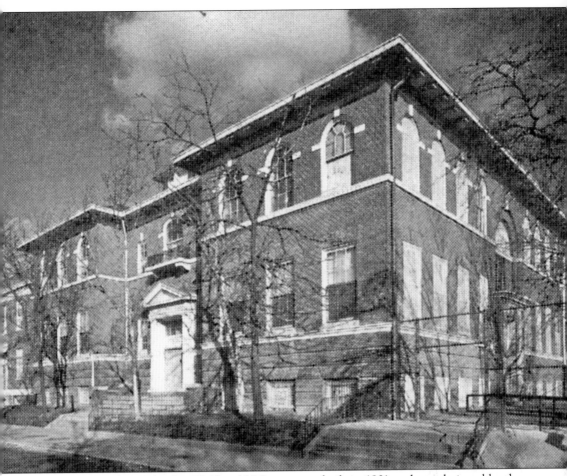

The William Syphax School at Half and N Streets was built in 1901 and was designed by the local architectural firm of Marsh and Peter. Built during an age of segregation, it was intended to serve a black student population and was named after the first black school trustee, who served from 1868 to 1871. (Author's Collection.)

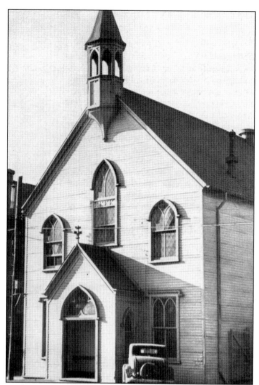

Southwest D.C. was the original location of the first D.C. morgue, built to resemble a chapel at the foot of Seventh Street and Water Street in 1904. Previously bodies were collected and kept at various police station stables for identification. The first "morgue master" of the city, William Schoneberger, suggested the city built a chapel-like structure, complete with stained glass, in an effort to soften the emotional identification of bodies by the next of kin. The location was chosen because of the frequent drowning of victims in the Potomac, only to be surpassed by individuals being killed by the increasing use of automobiles in the early 20th century. (D.C. Medical Examiner's Office.)

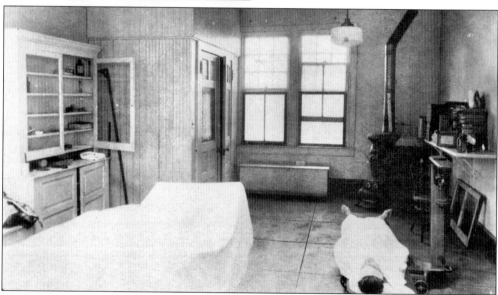

This image of the autopsy room at the Water Street Morgue shows the primitive methods of examination of bodies at the time. The building featured an ice-cooled refrigeration room, inquest room, and morgue master's office on the ground floor. A small cell was also located in the building for holding suspects in murder investigations, and bodies that were not claimed within seven days were photographed, fingerprinted, and donated to one of the medical collages in the city for research purposes. The building was torn down in 1940. (D.C. Medical Examiner's Office.)

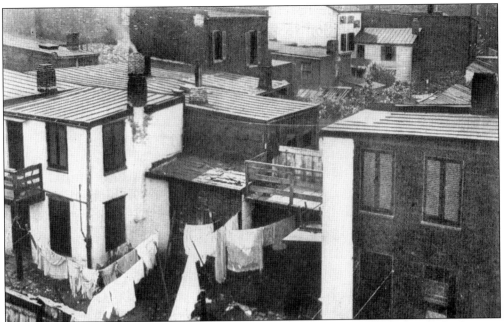

Burk's Alley was once located in the block surrounded by G and H Streets and Sixth and Seventh Streets, seen here. Author Charles Weller investigated one lot at 707 Burk's Alley in 1905 and found that it contained four houses on one lot, crowded with six families, which was perfectly legal before zoning codes were implemented. Weller and his wife, Eugenia, helped form the Colored Social Center in 1903 at 118 M Street, which evolved into the Southwest Community House years later. (Author's Collection.)

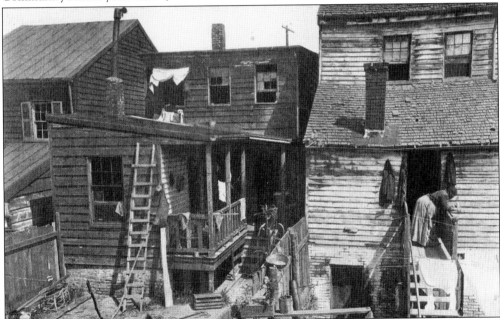

The dilapidated condition of many of the homes in Southwest and in the city itself can be illustrated by this 1905 photograph of those that were once located along K Street between Four-and-a-Half Street and Sixth Street. (Author's Collection.)

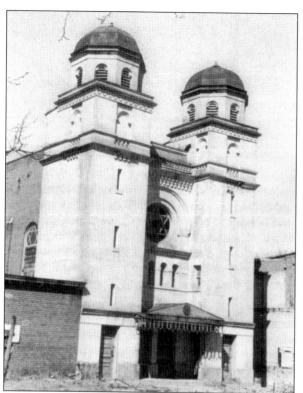

Once located at 467 E Street was the Talmud Torah Synagogue, built in 1906 to the designs of architect William L. Webster. The Washington Hebrew Congregation had been established in Washington in 1852, but the first synagogue was not built until 20 years later in Northwest D.C. German Jewish immigrants had begun to populate Southwest D.C. in the 1840s, opening businesses along Fourth Street. Other European Jewish immigrants created a critical mass, and this orthodox building was built. The name roughly translates as "study the law." Rabbi M. Yoelson, father of entertainer Al Jolson, directed the synagogue until 1912. The building was razed in 1959 as part of the Southwest urban redevelopment. (Photograph by Lawrence E. Gichner, LOC.)

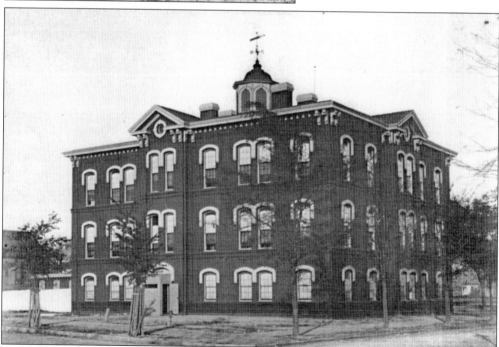

The Randall School was once located on I Street between Delaware Avenue and First Street. Seen here is its west elevation, photographed about 1908. Its black students moved to Jefferson Junior High School in 1954 with enforced integration. (LOC.)

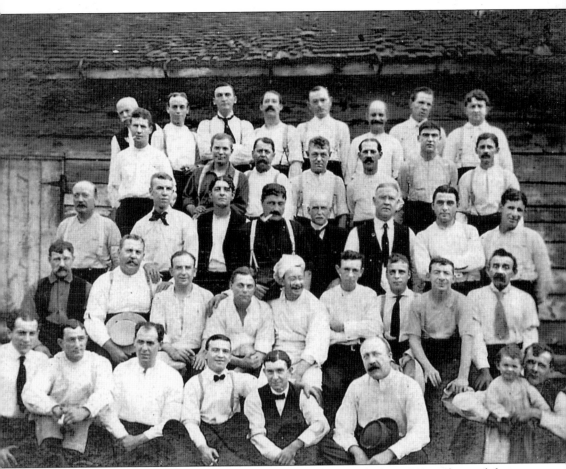

Members of the Social Oyster Club are pictured here sometime before 1910 in front of their original clubhouse next to the old Bureau of Printing and Engraving building on Fourteenth Street. Plate printer John Strack is sitting in the front row on the right with the hat in his lap. The club was organized in 1900 by a dozen plate printers employed by the bureau, including Strack. His grandson remembers a sign over the bar that read "A Noisy Noise Annoys an Oyster." It was described in the *Washington Post* as a "most exclusive and unique organization" and was known for its lavish oyster feasts. Their first home had been an old blacksmith's shop near the bureau on Fourteenth Street, but by 1910, their new clubhouse at Twelfth Street and Rhode Island Avenue, NE, was specifically designed for social purposes and was officially opened by 500 members and guests, including members of Congress and Samuel Gompers, the president of the American Federation of Labor. (Private collection of Steve Strack.)

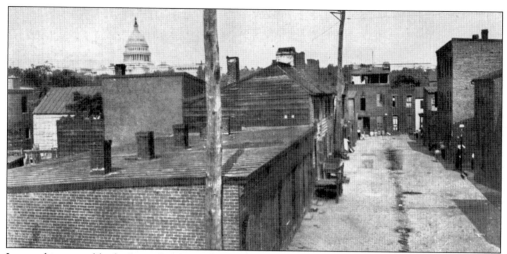

Located just two blocks from the Capitol grounds was a notorious alley called Willow Tree Alley, despite the absence of any trees whatsoever. Pictured here in 1908, it was a block surrounded by B and C Streets and Third and Four-and-a-Half Streets. (Author's Collection.)

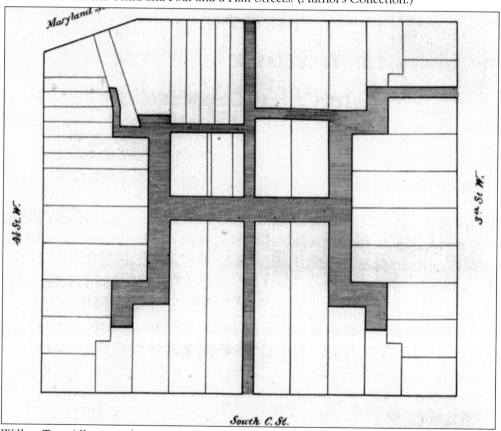

Willow Tree Alley, seen here in the dark lines of the interior of the block, was surveyed in a police census in 1897 and was found to have 328 inhabitants. By 1908, however, its population had increased to 501 inhabitants, including 228 black people and 273 whites, most of who were noted to be recent immigrants. (Author's Collection.)

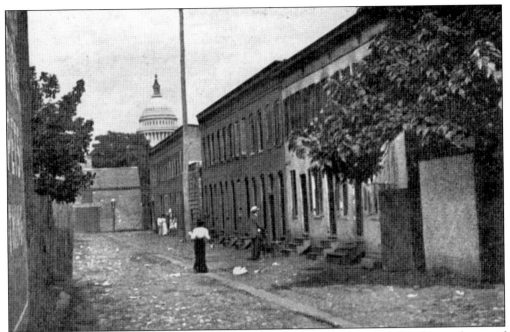

Louse Alley, or sometimes called Armory Place, was located just three blocks southwest of the U.S. Capitol and was described by Charles Weller in his 1909 book *Neglected Neighbors* as having "crowded houses for Italian laboring men standing close beside the bawdy houses of colored women." (Author's Collection.)

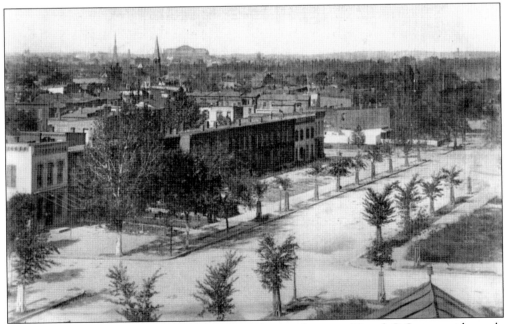

This view, taken about 1910, shows Delaware Avenue between H and G Streets with newly planted trees. It was taken from the roof of the Randall School looking northwest, with what today is the National Building Museum visible on the horizon in the background. (LOC.)

This image shows the busy D Street side of the Baltimore and Potomac Railroad Freight Station, once located at Maryland Avenue between Ninth and Tenth Street. The image was taken about 1915. (LOC.)

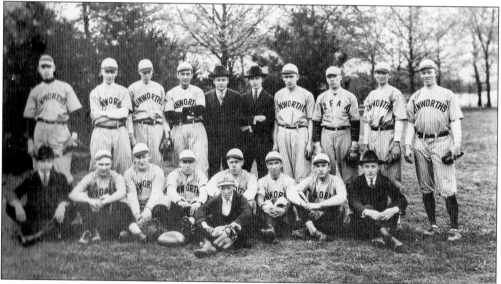

The baseball team called the Linworths is seen here about 1920. It was named after Linworth Place, SW, a small street located between Fourteenth and Thirteenth Streets. Albert F. Strack, a clerk at the Department of Agriculture, is shown sitting at the far right in the suit. From 1920 to 1930, the Strack family lived at 206 Linworth a two story, two bedroom brick dwelling lit by gas and heated by coal. Steve Strack Jr. recalls that it housed his father, his older brother, their parents, and, by 1930, three grandparents. (Private Collection of Steve Strack.)

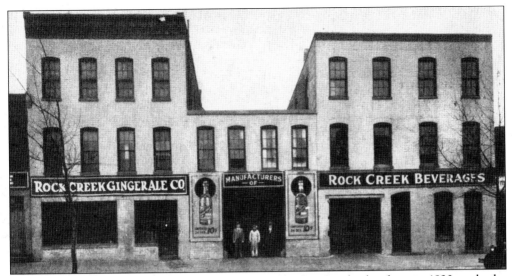

The Rock Creek Ginger Ale Company was started by four Rawley brothers in 1920, and sales immediately took off; by 1930, they had this 27,000-square-foot manufacturing plant at 209–217 Seventh Street, SW, in full operation. (Author's Collection.)

Members of the Capitol Yacht Club hired the architectural firm of Clarke and Clarke in 1922 to design for them their first meeting house at 1000 Water Street, seen here. The club was organized on the yacht coined *The Alert* in 1892 and met for a long period in the Southwest boathouse owned by Tony Ritter. The club was known for its annual round-trip 140-mile race to Annapolis. (LOC.)

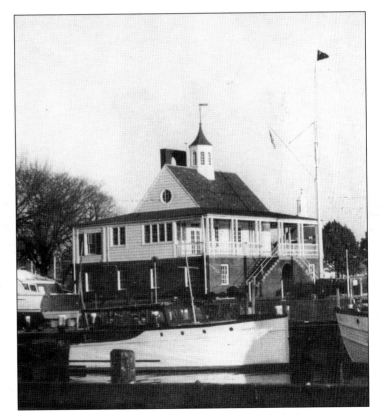

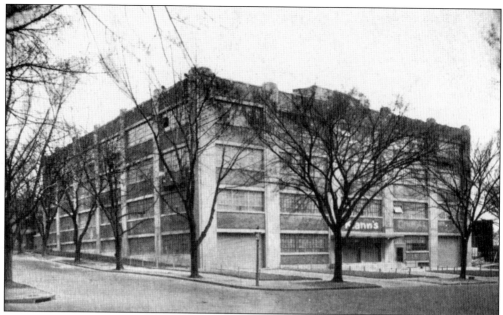

The well-known and beloved Kahn's Department Store at Pennsylvania Avenue and Eighth Street constructed the warehouse seen here at Delaware Avenue and C Street in Southwest in 1926 in an effort to relieve traffic around their main location. The fireproof building served both as a delivery station and warehouse and had about 102,000 square feet of space. (Author's Collection.)

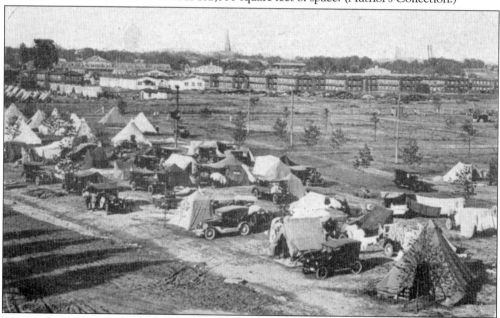

The southern portion of Potomac Park served for many years as a popular tourist camp beginning in 1921, when Congress appropriated $10,000 for its operation. Americans were mobile like never before with affordable automobiles, and it was typical to take the family camping in such environs as Washington. Then, as now, Washington, D.C., was a popular destination; the superintendent's report for August 1926 listed 7,101 cars parked there for at least one night, with a total of 18,983 occupants. (Author's Collection.)

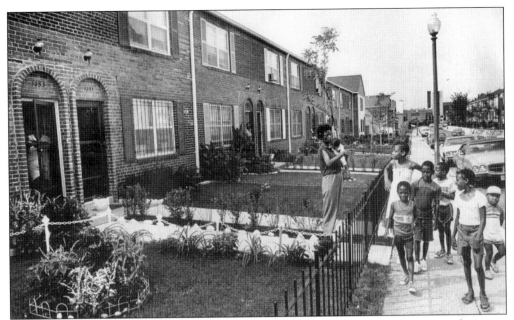

The James Creek project was one of the survivors of the Southwest urban renewal project, having been built just before World War II. The houses were rehabilitated in the late 1970s by D.C. housing officials weary of again relocating residents in the community as they had 20 years earlier. (Photograph by James Parcell, MLK.)

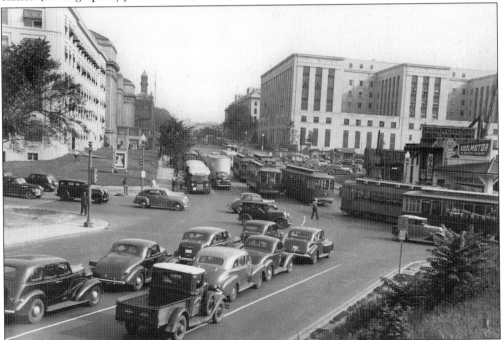

This view of the confusing intersection found at Fourteenth Street and Maine Avenue, looking north at the base of the Fourteenth Street Bridge, was taken 1940 by city officials to study methods to relieve the combination of heavy traffic and trolley cars. The gas station and coal yard seen at right were razed shortly thereafter. (Photograph courtesy DDOT.)

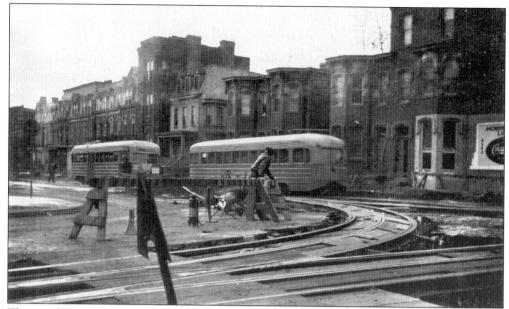

The installation of a new streetcar line along Independence Avenue between Sixth and Seventh Streets can be seen in this 1941 photograph. As part of the project, the row of homes and businesses seen in the background were razed for the widening of Independence Avenue, and the site today is occupied by the Department of Education building. (HSW.)

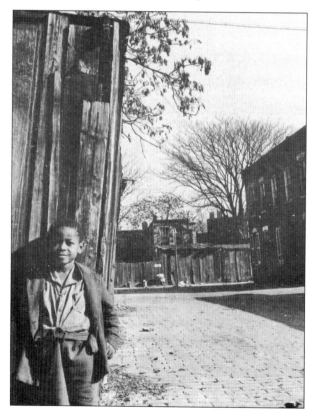

Famed photographer Gordon Parks captured this image of a Southwest alley resident in 1942 as part of his work for the Farm Security Administration. Like in other sections of the city, alleys with literally hundreds of occupants were often hidden from view in the center of large city blocks. (LOC.)

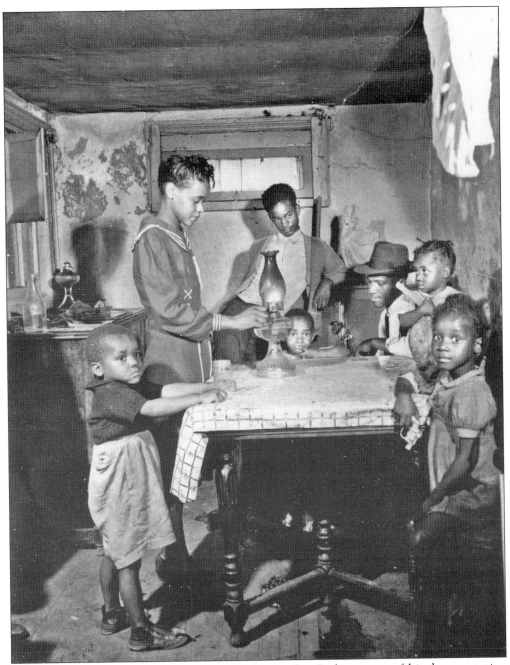

This family was photographed in June 1942 by Gordon Parks as part of his documentation work for the Farm Security Administration. It depicts a young family of seven living in a deteriorated home without the benefit of electricity. (LOC.)

The corner of N and Union Streets was part of the predominately Jewish section of southwest. It was photographed by Louise Rosskam in 1942 as part of her work for the Office of War Information. (LOC.)

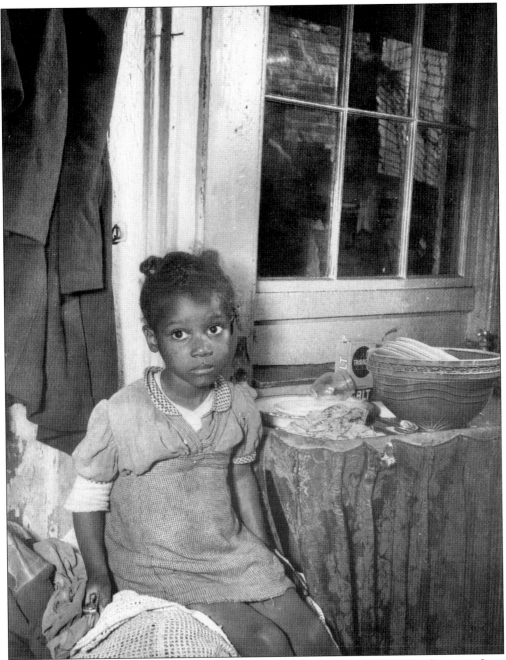
Photographer Gordon Parks captured this forlorn-looking young girl in her home in June 1942. (LOC.)

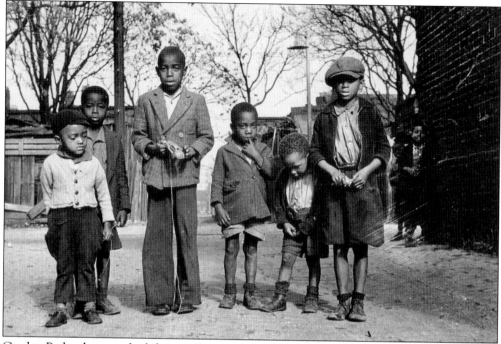

Gordon Parks photographed these well-dressed Southwest neighborhood children in November 1942. A year earlier, Parks had received the prestigious Rosenwald fellowship, choosing to document black life and culture through the Farm Security Administration. (LOC.)

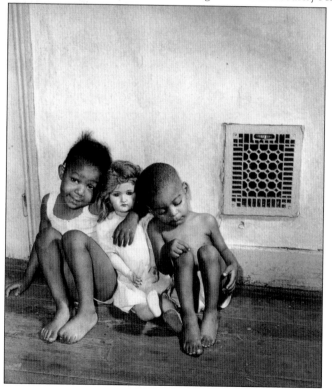

Gordon Parks took this image in Southwest in November 1942. The children were the grandchildren of Ella Watson, a government charwoman Parks photographed and documented to illustrate the plight of typical blacks in Washington at the time. (U.S. Office of War Information, LOC.)

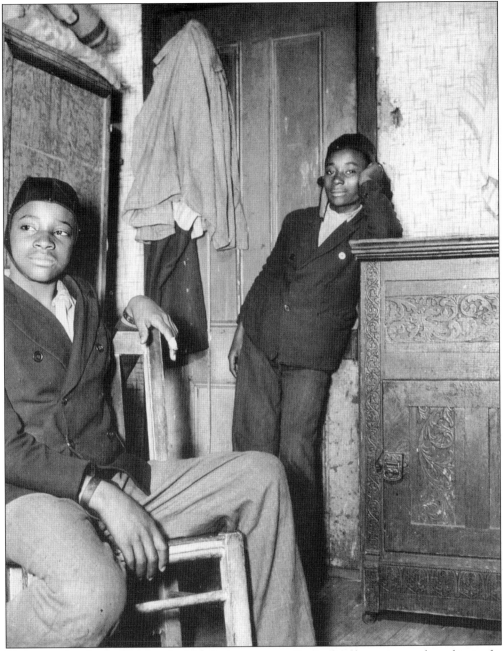

These two brothers, photographed in their one-room flat in Southwest, were the subject of a Gordon Parks photograph dated November 1942. (U.S. Office of War Information, LOC.)

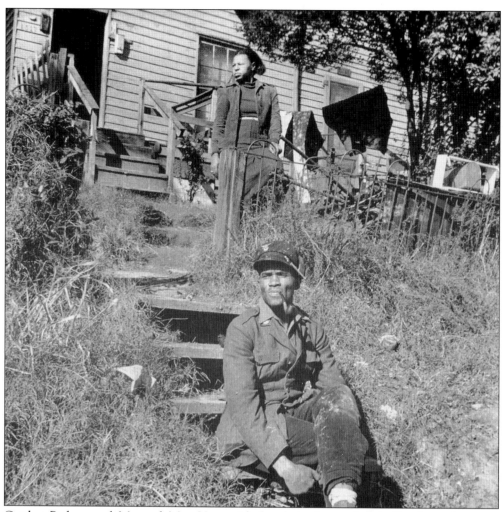

Gordon Parks posed Mr. and Mrs. Venus Alsobrook in front of their Southwest home in November 1942; Venus served as an official salvage collector for the government, part of a World War II effort to collect scrap for the war effort. (LOC.)

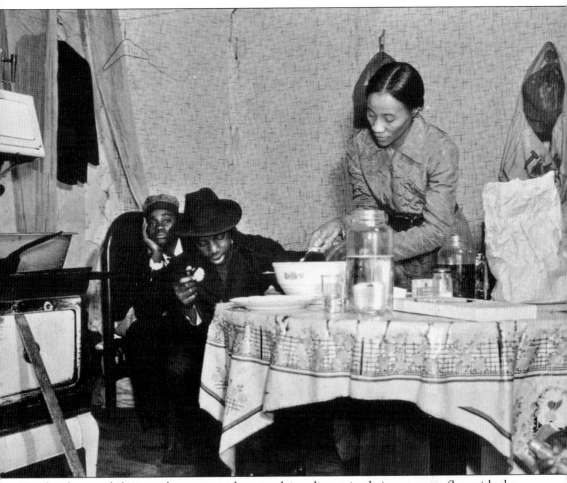

Two brothers and their mother are seen here readying dinner in their one room flat, with the oven door apparently needing a wooden stick in order to stay closed. (Gordon Parks, U.S. Office of War Information, LOC.)

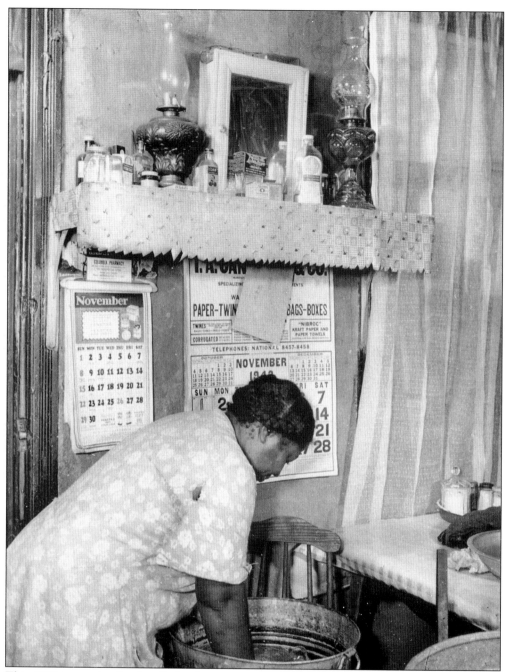

This 1942 image by Gordon Parks shows a woman washing her clothes in her kitchen. Like many other residents of Southwest, her home had no electricity, and she used the kerosene lamps, seen on the shelf, for illumination at night. (LOC.)

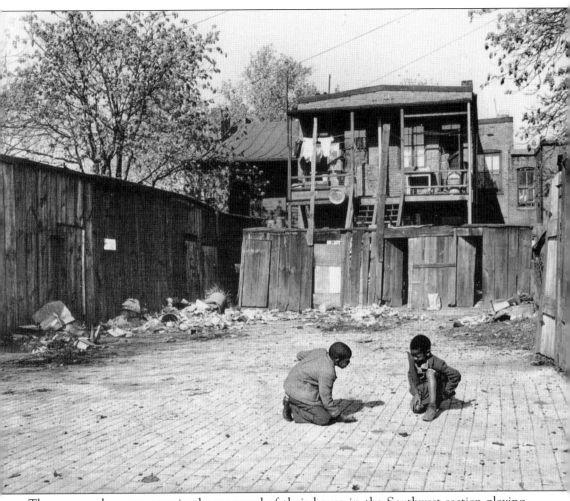

These young boys are seen in the rear yard of their house in the Southwest section playing marbles in this image by Gordon Parks taken in November 1942. (LOC.)

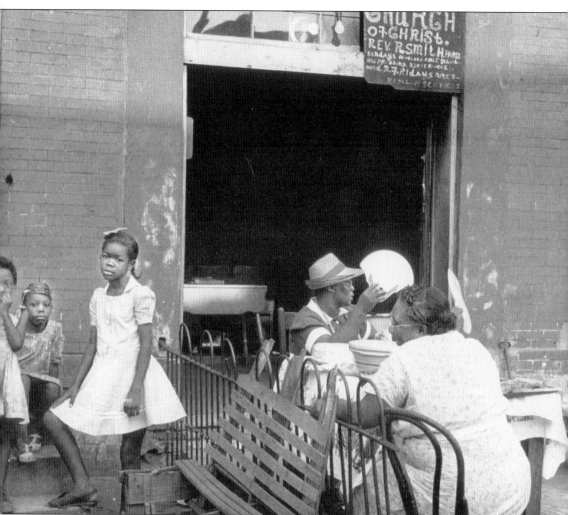

Parishioners of the Holy Church of Christ in Southwest were photographed by noted photographer Godfrey Frankel in 1943. Rev. R. Smith preached at the location every Sunday, Wednesday, and Friday at the alley location in what was called a storefront church. (LOC.)

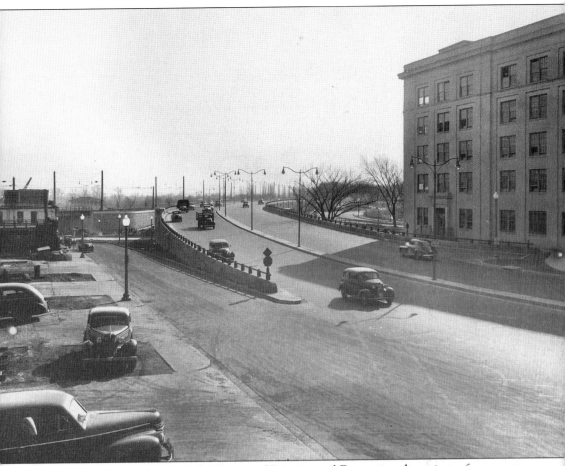

This image, taken in 1943 near the Bureau of Printing and Engraving, shows just a few cars on the Fourteenth Street Bridge coming and going to Virginia. Double-armed street lights on the center of bridge added an almost suburban feel to what is one of the most heavily trafficked intersections of the city today. (Photograph courtesy DDOT.)

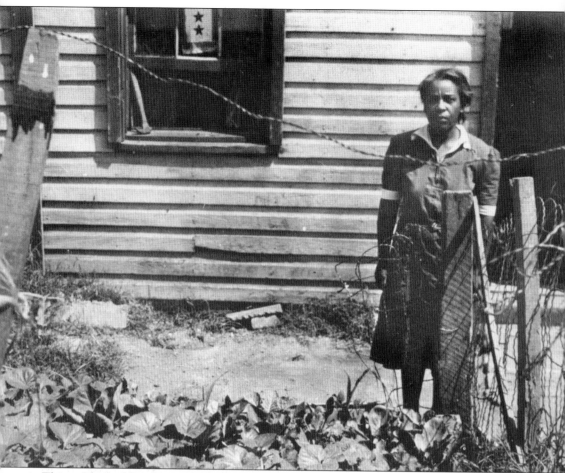

This resident of Southwest Washington overlooks her victory garden while proudly displaying two stars in her window, which were placed to denote that two men in the family were serving as part of the war effort. As late as December 1944, the government announced that all chickens produced in Virginia, West Virginia, and Delaware would be bought by the Army Quartermaster Corps. (LOC.)

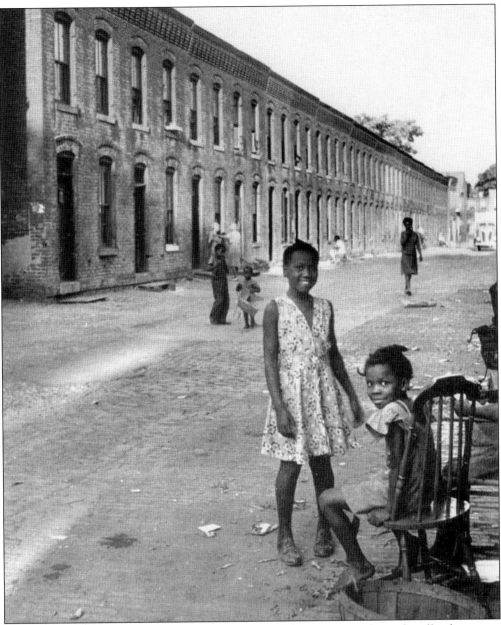

Noted photographer Godfrey Frankel photographed these young girls in the alley known as Dixon Court, where families in similar financial circumstances always looked after one another in a self-sufficient manor. (LOC.)

The rather dingy loading platform of the Fourteenth Street underground street car terminal was photographed in March 1945 to illustrate conditions found in the city following World War II that were a result of temporary measures to address a quick influx of workers. (Photograph courtesy DDOT.)

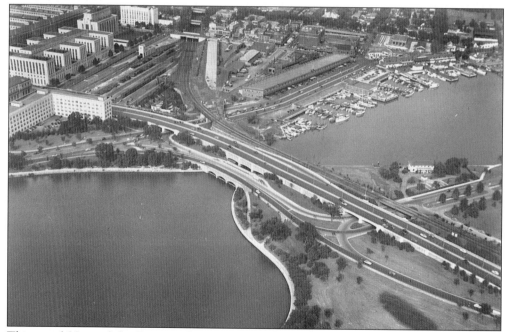

This aerial View of the Fourteenth Street Bridge was taken from a blimp, whose shadow is visible at the right. The image was taken on June 9, 1948, at 5:17 p.m. from an altitude of 650 feet to record traffic flow across the bridge on a typical rush hour day. Washington Marina is visible at the upper right. (Photograph courtesy DDOT.)

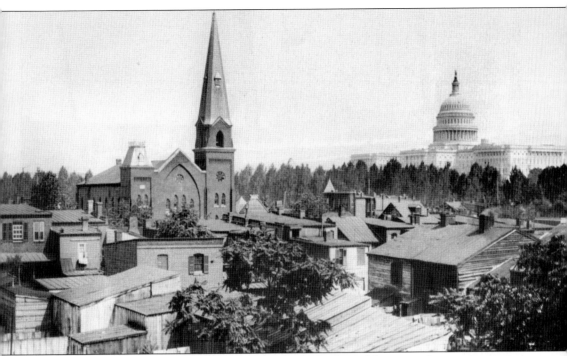

The Southwest community's location close to the U.S. Capitol has served as an interesting juxtaposition with its small-scale wood-frame and brick working-class housing. Its dramatic contrast to the federal government buildings were the subject of many photographic essays. Shown here is the Wesley Zion Church on D Street between Second and Third Streets, with the James Creek Canal running under the trees to the right. (LOC.)

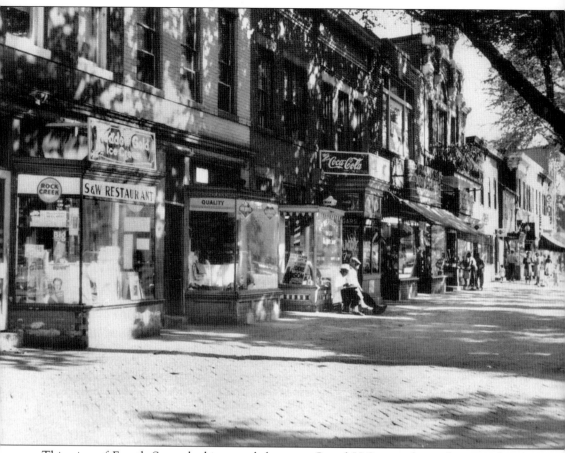

This view of Fourth Street looking south between G and H Streets shows the once-thriving business corridor that was lined with a variety of shops. Today it is the site of the Capitol Park Apartments. (Photograph by Joseph Owen Curtis. MLK.)

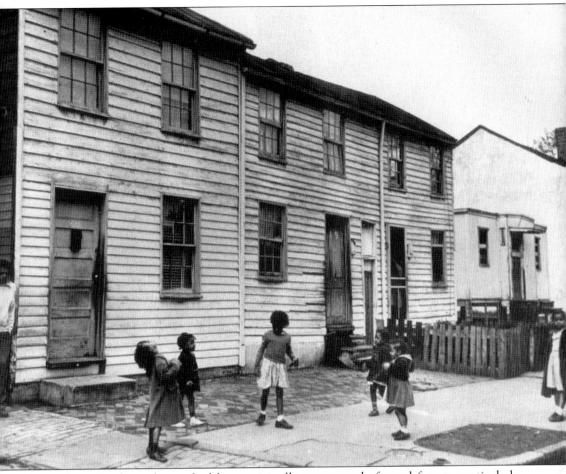

Many of the Southwest homes had been originally constructed of wood frames, particularly vulnerable to insect and flood damage and with a limited life expectancy if not properly maintained. These homes were photographed in 1949 at 217 to 221 F Street. (MLK.)

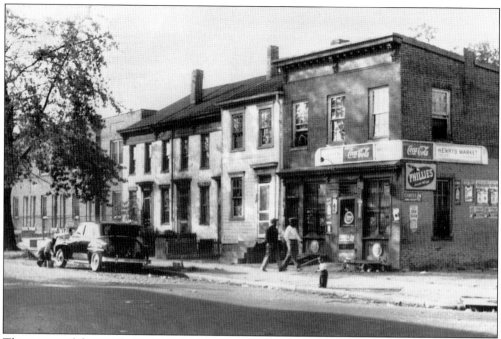

This image of the northwest corner of Second and F Streets was taken in 1951, just a few years before it was demolished as part of an 80-acre pilot project in urban renewal. Today the site is situated under the Southwest Freeway. (Photograph by Joseph Owen Curtis, LOC.)

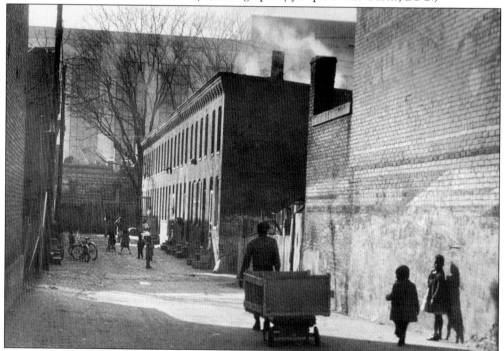

This image shows an alley between B and Half Streets in March 1951, ironically with the Health and Human Services Building seen in the background, which was originally built for the Social Security Administration. (MLK.)

Six

URBAN RENEWAL AND REBUILDING SOUTHWEST

Many attempts had been made at improving the conditions of the deteriorating Southwest community long before the well-known systematic razing of the area in the 1950s. The Washington Sanitary Improvement Company had worked hard at raising funds and building adequate and affordable housing in the community as early as 1911, as it did in other neighborhoods of the nation's capital. It was one of the first such development corporations to target black working-class families in desperate need of affordable housing at the time. Its efforts stemmed from the early documentation of the ill effects of alley life by Charles Weller and his wife, who both established Southwest programs to provide for the poor.

However, what Southwest is criticized by some and heralded by others for is the widespread urban renewal that called for the demolition of thousands of individually owned buildings and the displacement of nearly 30,000 individuals in the 1950s and 1960s. They not only lost their homes and sense of community but their livelihood as well. Businesses and commercial structures were also demolished along with the vast majority of religious houses of worship.

What some saw as a travesty and worked hard to eliminate in other large cities as urban renewal policies took hold, Washingtonians saw as an opportunity to rebuild a community on a clean slate, using modern materials and concepts to house a massive urban population in the city. Private developers and land speculators also saw an economic boom for themselves on property reclaimed through eminent domain and available for well below the market rate in exchange for a promise to build. While the results were both successful and unsuccessful as tested by time, the majority of residents moving to Southwest in the 1960s were those who were not displaced 10 years earlier. As time has again passed, a new generation of preservation-minded individuals and residents alike have begun efforts to ensure that the buildings of Southwest constructed in the 1950s and 1960s remain in order to begin to assess its historic significance as one of the more unusual planned communities found in the United States.

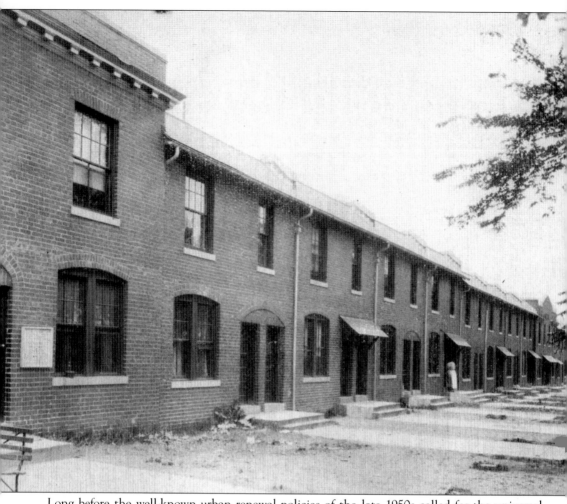

Long before the well-known urban renewal policies of the late 1950s called for the universal razing of all structures, many development companies with a social conscience were at work renovating and creating new homes for the Southwest population without displacement of its residents. Seen here is the Washington Sanitary Housing Company's newly completed row of homes in 1914 on South Capitol Street. Especially constructed for black tenants, they were offered as affordable rentals that year at a cost of $14 per month for a three-bedroom apartment with bath, well below the going rate at the time. (Author's Collection.)

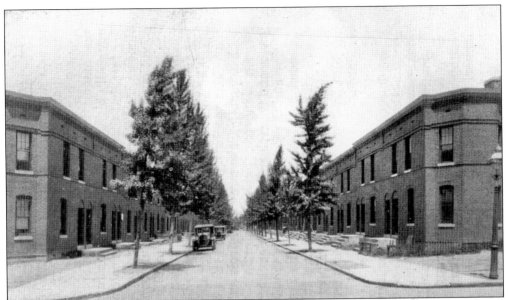

The Washington Sanitary Housing Company had been incorporated in 1904 to "build sanitary houses for a deserving class of the population which can not afford to pay the rentals of from $14 to $22 per month," the going rate at the time. Ten years later, the company built these houses on Carrolsburg Place between M and P Streets in Southwest especially for black tenants, charging between $10.50 and $11.00 for a two-bedroom flat with bath. A four-bedroom flat rented for $16 per month. (Author's Collection.)

The Washington Sanitary Housing Company also built these 20 townhouses on M Street between South Capitol and Half Streets in 1911. They featured rents from $11.50 per month for a two-bedroom flat to $17.50 for a four-bedroom or $50 a month for a storefront with flat above. All of the homes were built for the local black community and featured an open porch on the rear of the property. (Author's Collection.)

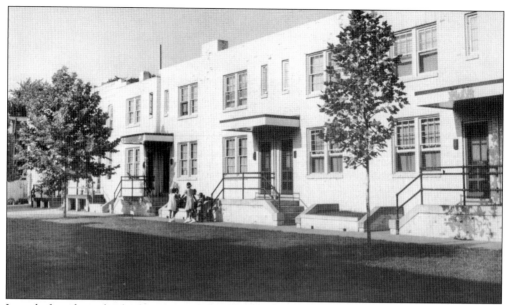

Long before the radical urban renewal development took place in Southwest in the 1960s, many attempts were made at replacing substandard housing, including the Hopkins Place Housing Project, seen here shortly after it was completed in 1941. (LOC.)

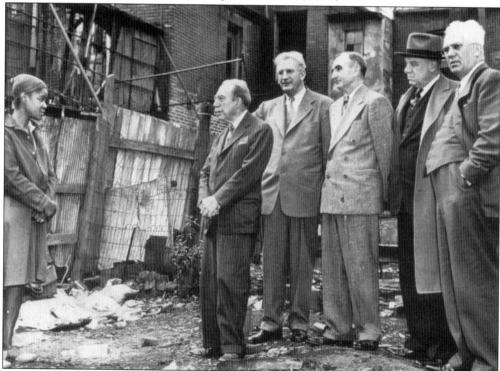

As might be expected, predominantly white governmental officials were toured throughout Southwest to witness firsthand the conditions of the city's poor. A photographer captured this rather awkward tour by officials talking to a Southwest resident; from left to right are Senators Theodore Green, Paul Douglas, Wayne Morse, Raymond Baldwin, and Homer Ferguson. (MLK.)

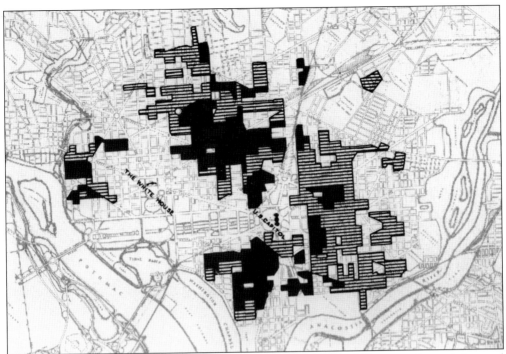

This 1950s map was delineated by the National Capital Park and Planning Commission and shows areas in black where they estimated that over 50 percent of the housing stock needed major repairs and lacked a private bath. How they determined that was clearly subjective. The areas with crosshatching were neighborhoods with "blighted characteristics." Most of Southwest fell into the two categories, and it was the focus of a major urban renewal process that called for the vast majority of the community to be relocated and the buildings systematically razed. (NCPC.)

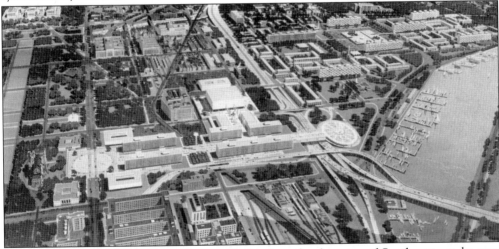

The extensive William Zeckendorf proposals for the redevelopment of Southwest can be seen here in this aerial conception drawing from 1955. It was conceived by the New York developer between 1954 and 1959 in an area coined "Project C." He envisioned entrance to Southwest via the Tenth Street Mall and housing for 4,000 families of various income levels. His New York-based real estate empire crashed, however, before plans could be realized. (NCPC.)

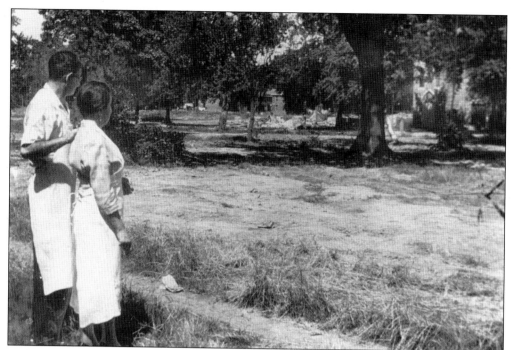

Multicultural residents were displaced in the urban renewal efforts of Southwest. Here Ezra Lazer and her brother-in-law, Samuel Holstein, are posed by a *Washington Star* photographer in June 1956 looking on vacant land where patrons of their grocery-store business once lived. (MLK.)

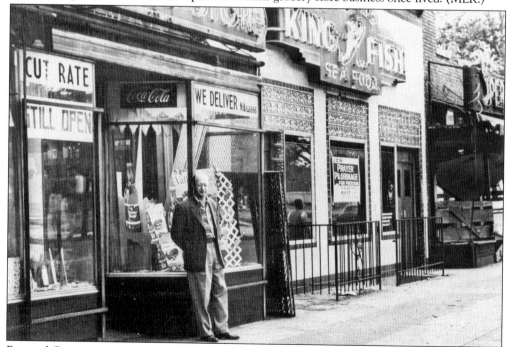

Bernard Green is seen here in 1957 posing in front of his liquor business at 624 Fourth Street, once the center of a vibrant Jewish-owned business center. His was the last store open on the block before it was razed for redevelopment. (MLK.)

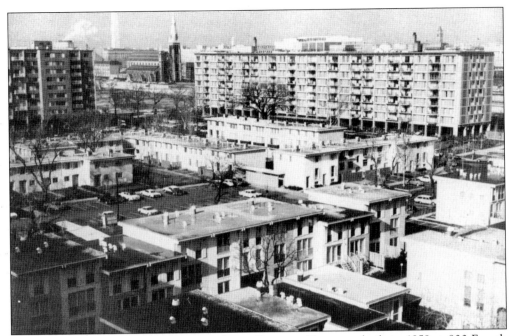

The completed vast complex known today as Potomac Place was built in 1958 at 800 Fourth Street as Capitol Park. It was the first of the new projects in the razed areas of the neighborhood, seen here in the mid-1960s. Images of Southwest were used by Russian leaders as propaganda during the Cold War to illustrate the ill effects of capitalism. (DCHCD.)

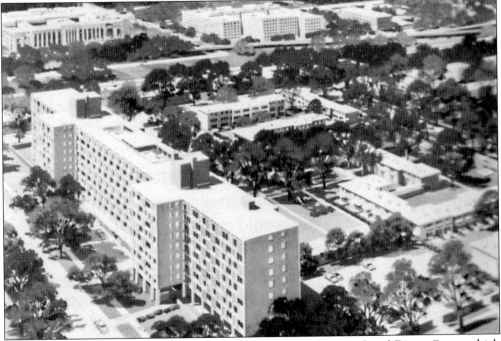

Designed by Satterlee and Smith, Capitol Park (Potomac Place) replaced Dixon Court, which was often used as an example of the blighted neighborhood without regard to the human element or family orientation. (MLK.)

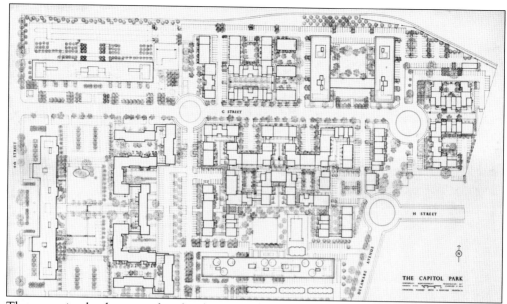

The extensive landscaping plan for the Capitol Park housing complex is illustrated here; an entirely new plan was possible because of the cleared and vacant land. (LOC.)

The principal in the architectural firm of Satterlee and Smith, Chloethiel Woodard Smith, was a woman who had the vision to redesign an entire community on recently vacated land. She is responsible for much of what is visible in Southwest today, including the Capitol Park complex on Fourth Street. Critics applauded her design. It was the first development in the community and featured such innovative elements as folding walls that separated bedroom areas in the efficiency units. (MLK.)

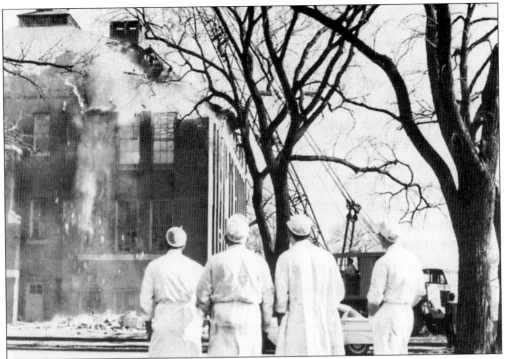

With most of old Southwest already cleared, these uniformed employees of the Briggs Sausage Company watch as the Fairbrother Elementary School is razed on February 3, 1960. (DHCD.)

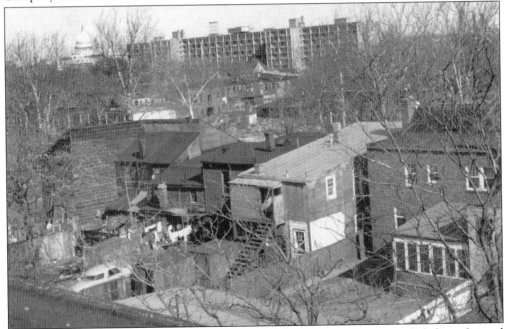

Not all of the Southwest neighborhood was razed at one time, as many people believe. Instead it was a process that took more than a decade, often with new high-rises coexisting along with century-old housing stock, as seen in this c. 1960 photograph. The Capitol Park high-rise is seen in the background. (MLK.)

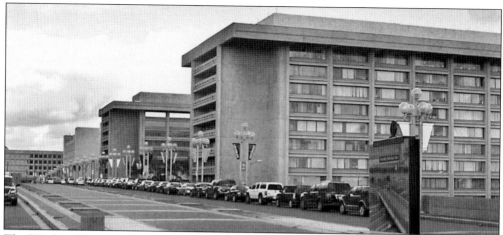

The L'Enfant Plaza complex is perhaps better known for its Metro Station name than the once-grand office complex, hotel, and promenade that was first envisioned by architect I. M. Pei and Associates when building began in 1965. An outgrowth of the Zeckendorf-Pei plan for Southwest, the promenade that was envisioned was terminated at the exit ramp for Interstate 395 and remains an anomaly of urban vision from the 1960s. The Dan Kiley landscape firm designed its mostly concrete grounds in 1968, and the hotel and west office complex were opened in 1973 to the designs of Vlastimil Koubek. Southwest residents and tourists headed to the metrorail station from the waterfront continue to scale an unlandscaped hill on a dirt path from the popular Maine Avenue waterfront almost 40 years later. (Author's Collection.)

The Arena Stage building at Sixth and M Streets was built in 1961 and was designed by Harry Weese and Associates, who were also the designers of Washington's Metro system. Started earlier in Northwest, Washington, D.C., the stage violated local practice and policies by insisting on an integrated audience beginning in 1951. It had been founded by Zelda Fichandler the previous year. In 1967, their play *The Great White Hope* won a Pulitzer Prize and launched the career of James Earl Jones. (Author's Collection.)

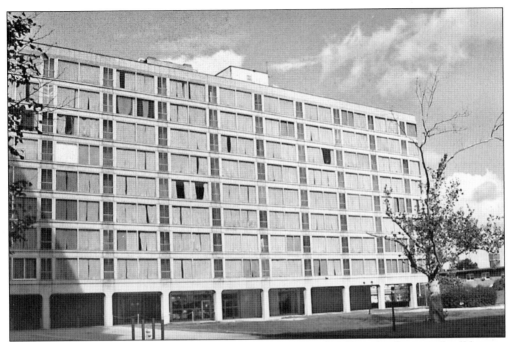

The Town Center Plaza was originally built between 1961 and 1962 to the designs of well-known architect I. M. Pei as an apartment complex. Chloethiel W. Smith designed a larger commercial complex on the site in 1972. (Author's Collection.)

The River Park complex began construction in 1962 and opened as a cooperative apartment complex the following year with a range of high-rise tower units and low-rise townhouses characterized by their distinctive barrel-vault roofs. When opened, its tenants worked to ensure a diverse population purchased its units. It is located between Delaware Avenue and Fourth Street. (MLK.)

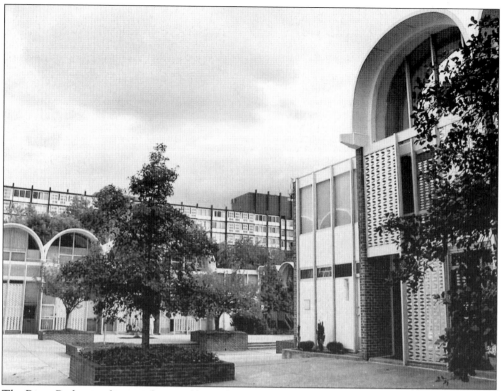

The River Park complex was designed by architect Charles M. Goodman, who utilized aluminum from the Reynolds Metals Company on its façade design in what was one of the more unusual characteristics of the cooperative. (Author's Collection.)

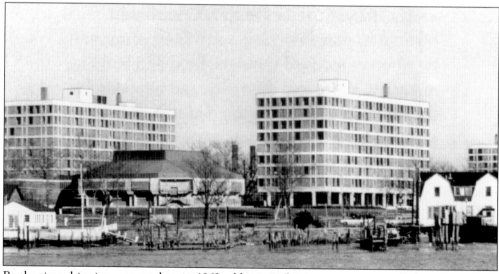

By the time this picture was taken in 1962, older waterfront structures were all that remained in the area surrounding Marina View Towers and Arena Stage. They have since been razed. (MLK.)

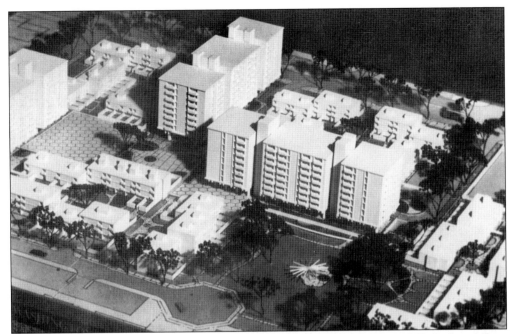

The model for the Carrollsburg Square Development is pictured here in 1965. It shows plans that called for spacious open green areas and paved plazas without a car in sight, as designed by the architectural firm of Keyes, Lethbridge, and Condon. They had won a design competition held by the site's developer, Charles H. Tomkins. (DCHCD.)

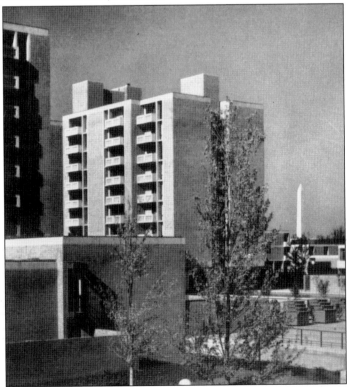

The Tiber Island cooperative complex was built in 1965 at 429 N Street and incorporated the c. 1794 Thomas Law House into its design. The complex was designed by the architectural firm of Keyes, Lethbridge, and Condon. (NCPC.)

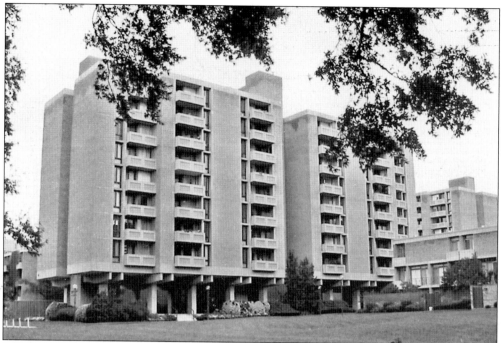

Tiber Island was awarded two individual prizes in the Redevelopment Land Agency competitions upon completion in 1965. The combination of apartment towers and townhomes surrounding a covered central plaza was innovative for the time. (Author's Collection.)

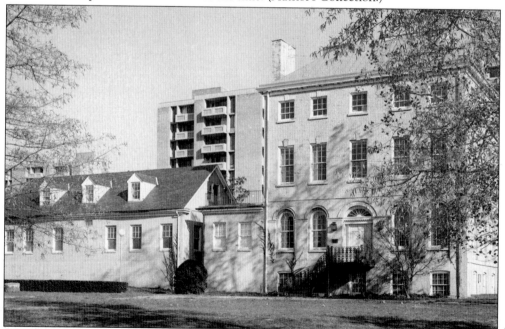

The c. 1794 Law House was saved from demolition by local preservationists and incorporated into the Tiber Island Cooperative. It served as the medical clinic of Dr. Hadley for many years. Seen here in 1974, the house now serves as a central community entertainment and social center. (LOC.)

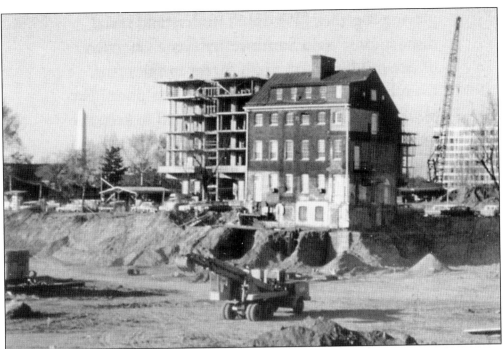

The *c.* 1794 Duncanson-Cranch house is seen here while undergoing extensive renovations as part of its inclusion into the Harbor Square complex in 1963. Note the uncovered extensive foundation walls that once supported additional buildings on the site. (HSW.)

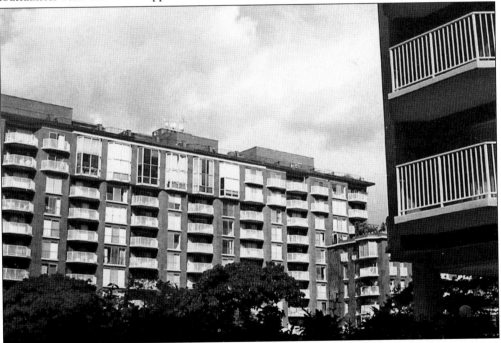

The Harbor Square complex was built with an impressive 443 individual units with 127 different floor plans. Most units have spectacular views of the waterfront and the National Mall. (Author's Collection.)

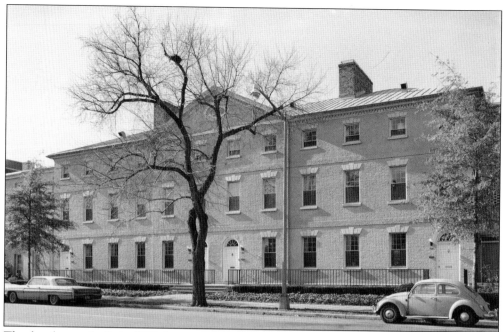

The four houses built in 1795 that constituted Wheat Row were incorporated into the Harbor Square complex as the development's largest condominium townhouse units. They retain much of their interior architectural elements, and today their lower level opens directly inside of a modern parking garage. (LOC.)

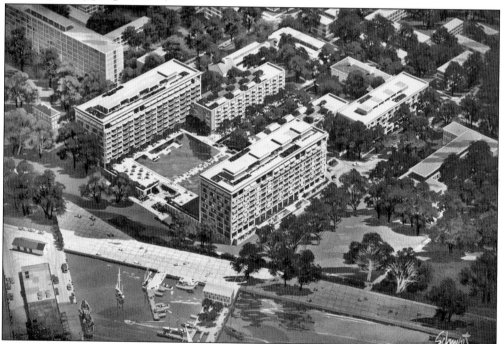

The enormity of the Harbor Square complex can be seen in their bird's-eye view drawn for various public meetings before the complex was built. Its courtyards feature large reflecting pools and fountains. (LOC.)

126

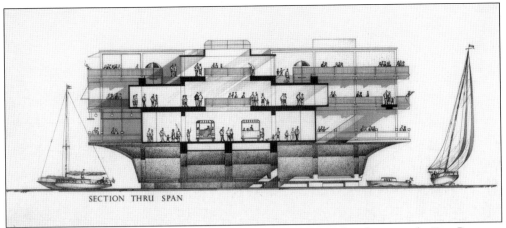

SECTION THRU SPAN

This cross section of a proposed multi-layered bridge to connect Southwest to the East Potomac Park was drawn in 1966 by architect Chloethiel W. Smith. It included a tunnel for buses, and rental income from shops along its exterior was hoped to pay for the bridge itself. The ambitious design was never realized. (LOC.)

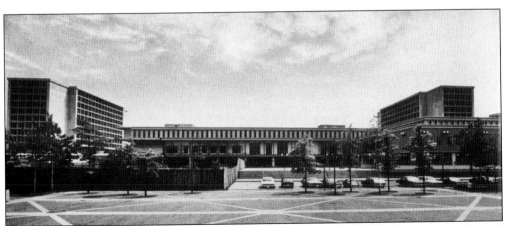

The Waterside Mall was built to replace the Four-and-a-Half Street commercial corridor and housed professional offices, a grocery store, and small businesses. The Metro station was later built underneath the center, which has become out of date for today's shopping needs. Plans now call for a complete renovation of the building. (MLK.)

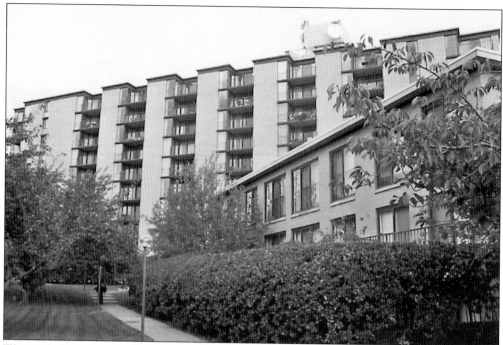

Waterside Towers was also designed by C. W. Smith in 1970. The *U*-shaped apartment complex faces an interior courtyard with a few rowhomes and is located at 905–947 Sixth Street. (Author's Collection.)

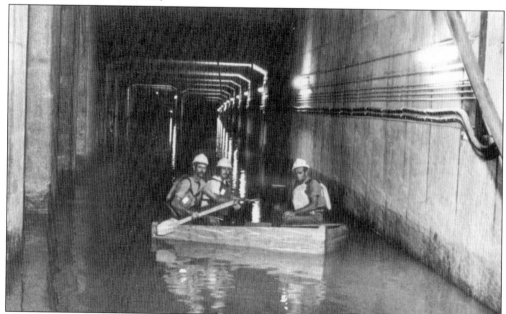

During Metro construction in 1977, a winter delay in connecting the green and yellow line tunnels just south of L'Enfant Plaza to their raised-bridge counterparts left them vulnerable to flooding, which is exactly what happed on August 25, 1977. The water flowed downhill to a low point at Federal Center and rose to a height of four feet, seen here. (Photograph by Paul Myatt, MLK.)